IMAGES
of America

DOUGLAS/GRAND
BOULEVARD

A CHICAGO NEIGHBORHOOD

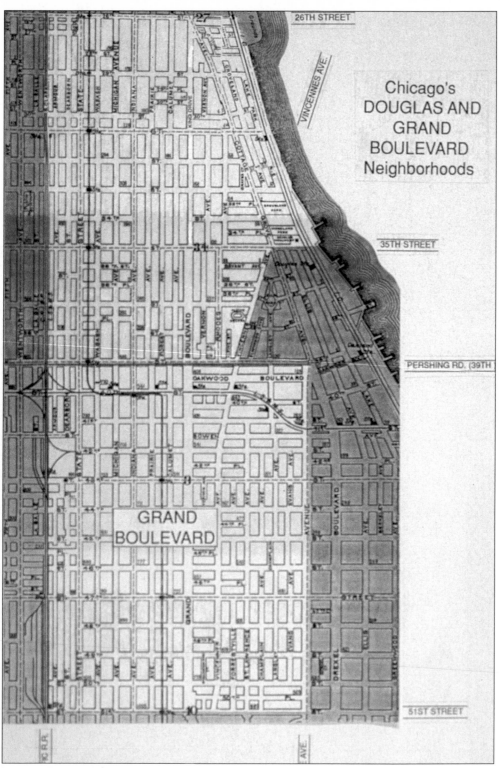

MAP OF DOUGLAS/GRAND BOULEVARD.

IMAGES
of America

DOUGLAS/GRAND BOULEVARD

A CHICAGO NEIGHBORHOOD

Olivia Mahoney
For the Chicago Historical Society

ARCADIA

Published by Arcadia Publishing,
an imprint of Tempus Publishing, Inc.
3047 N. Lincoln Ave., Suite 410
Chicago, IL 60657

Printed in Great Britain.

Library of Congress Catalog Card Number: 2001087166

For all general information contact Arcadia Publishing at:
Telephone 843-853-2070
Fax 843-853-0044
E-Mail sales@arcadiapublishing.com

For customer service and orders:
Toll-Free 1-888-313-2665

Visit us on the internet at http://www.arcadiapublishing.com

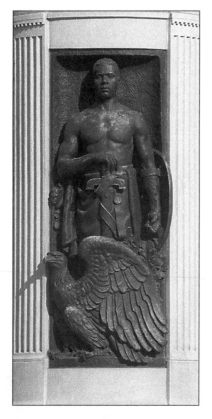

VICTORY (DETAIL), THIRTY-FIFTH AND KING DRIVE.
Located in the heart of Douglas/Grand Boulevard,
Victory commemorates members of the Eighth Illinois
Regiment who died in World War I, and serves as an
important reminder of African Americans' central role
in the nation's history.

CONTENTS

ACKNOWLEDGMENTS

In large part, this book is based on an exhibition I developed in 1995 with residents of Douglas/Grand Boulevard for the Chicago Historical Society (CHS) as part of its path-breaking project, *Neighborhoods: Keepers of Culture*. Like exhibitions, publications involve the efforts of many people and I would thank several members of the Chicago Historical Society staff for their assistance. Russell Lewis, Andrew W. Mellon Director for Research and Collections and Rosemary Adams, Director of Publications encouraged me to begin the project and supported my efforts throughout the process. Ms. Adams also edited the manuscript. John Alderson and Jay Crawford, CHS photographers, are responsible for all images in the book and, as usual, their work is first-rate. Lesley Martin, Rob Medina, Caroline Nutley, Steve Peters, and Keshia Whitehead of the Research and Access Department helped original materials and process them through the photo lab. It is always a joy to work with the collections of the Chicago Historical Society and with the dedicated people who care for them. In addition, Sylvia Landsman compiled two indispensable notebooks of images; Timothy J. Samuelson, Curator of Architecture; and Archibald Motley Jr., Archivist Emeritus; helped locate collection materials, read the manuscript for errors, and provided many helpful suggestions, as did Diane Dillon. I am especially indebted to the following individuals who graciously lent photographs: Timuel D. Black, Brother Michael Quirk, President of De La Salle Institute, Reverend Thomas Frayne, Pastor of St. James Church, Sister Joy of the Sisters of Mercy, George W. Noe, Timothy Samuelson, and Muriel B. Wilson. Finally, I would like to thank my family for their enthusiastic support and encouragement.

NOTE: ALL IMAGES IN THIS BOOK ARE FROM THE CHICAGO HISTORICAL SOCIETY, UNLESS OTHERWISE NOTED.

INTRODUCTION

The history of Chicago can be told through its neighborhoods, and perhaps none is more telling than Douglas/Grand Boulevard on the city's South Side. Like all of Chicago, the area once belonged to Native Americans, specifically the Miami and Potawatomi Indians, who lived throughout northern Illinois before white settlers arrived. Today, their presence is recalled by Vincennes Avenue, a former Indian trail that served as an important fur-trade route from the late seventeenth to the early nineteenth centuries. For the most part, however, the future site of Douglas/Grand Boulevard remained a sparsely settled prairie until the early 1850s, when Stephen A. Douglas purchased a large tract of land between Thirty-first and Thirty-fifth Streets, and began developing a residential subdivision for the wealthy. Douglas's death in 1861 and the Civil War stalled growth, but the Great Chicago Fire of 1871 spurred development as many residents from the central city moved south after losing their homes.

By 1880, the South Side had a diverse population of Anglo-Protestants, Irish Catholics, German Jews, and African Americans. Each community established businesses, houses of worship, schools, hospitals, and social service agencies that provided social stability for decades. In addition, many of Chicago's wealthiest families lived in the area, making it one of the city's most fashionable districts.

Around World War I, the neighborhood began to change dramatically as a result of the Great Migration, the mass movement of African Americans from the South to the urban North. Living in predominately white cities, they encountered many obstacles and outright hostility. In Chicago, long-simmering tensions erupted in the 1919 Race Riot; afterwards, an increasing number of whites moved away from the South Side, while others in surrounding neighborhoods kept blacks out by using restrictive covenants to prevent the sale or rental of property to any person of "color." As a result, residents of Douglas/Grand Boulevard lived behind a nearly impenetrable "color line" that separated them from white Chicago.

Despite the harmful effects of racism, Douglas/Grand Boulevard became a national model of black achievement. By 1925, the area known as Black Metropolis and later as Bronzeville, had over 100,000 residents, making it the second largest African-American community after Harlem in New York City. Although many entrepreneurs and professionals worked in the neighborhood, the vast majority of residents worked as semi-skilled laborers in the city's service and industrial sectors. Politically, neighborhood residents began to wield influence by electing African Americans to local, state, and national offices, including Oscar De Priest, the first black congressman since Reconstruction. A lively night scene attracted national attention, while Sunday morning church services provided residents with important social anchors.

Douglas/Grand Boulevard flourished until the Great Depression, which had an especially devastating effect upon black communities with fewer economic resources than white communities to weather the storm. By 1935, the neighborhood's unemployment rate reached 50 percent, and most black-owned businesses around Thirty-fifth Street had collapsed, never to recover. Meanwhile, many white-owned businesses that had sprung up along Forty-seventh Street during the 1920s survived the Great Depression, then flourished during the boom years of World War II. Politically, Douglas/Grand Boulevard experienced a dramatic change during the 1930s, as African Americans nationwide left the Republican Party for Franklin D. Roosevelt's New Deal Democrats, who championed fair treatment for African Americans and a general program of economic recovery for the entire nation.

During World War II, when factories once again hummed with activity, more than 30,000 southern blacks moved to Douglas/Grand Boulevard, causing severe over-crowding. A large number of people lived in cramped, one-room apartments called "kitchenettes," carved out of single-family homes; shared bathrooms, poor plumbing, and faulty wiring made these homes unsanitary and dangerous. For years, community leaders had lobbied the government to build low-income housing. Finally, in 1941, the Chicago Housing Authority opened the Ida B. Wells Homes; generally regarded as a successful effort, the project provided low-income African Americans with decent, affordable housing for the first time in Chicago history.

After World War II, Douglas/Grand Boulevard experienced profound change. Like many northern cities, Chicago embarked on a program of urban renewal to "save the city." On the South Side, neighborhood institutions, private investors, city officials, and the federal government joined together in a massive effort to rebuild the neighborhood, including the construction of high-rise public housing for tens of thousands of people. In quick succession, the Chicago Housing Authority constructed Stateway Gardens and the Robert Taylor Homes. At first, residents believed their conditions improved, but it quickly became apparent that the projects created as many, if not more, problems than they solved.

As urban renewal proceeded, additional factors contributed to the neighborhood's decline. After the U.S. Supreme Court struck down restrictive covenants as unconstitutional in 1948, thousands of middle and upper-income African Americans moved away from Douglas/Grand Boulevard to areas further south. The migration left behind lower-income residents, but it did not result in racial integration, as Chicago's white population continued its exodus to the suburbs. At the same time, Chicago's industrial base declined, resulting in permanent job loss for thousands of South Side residents. During the 1970–80s, Douglas/Grand Boulevard's unemployment rate reached as high as 90 percent.

Despite these massive problems, residents of Douglas/Grand Boulevard sought solutions to build a better future for themselves and their children. Many black churches remained in the neighborhood to provide much-needed services to local residents, while organizations like the NAACP, the Urban League, and Operation PUSH worked for civil rights, improved education, housing, and employment opportunities.

In recent years, sections of the neighborhood have been renovated. Its ideal location, excellent transportation, and historical importance have attracted middle and above-income residents, who are restoring many nineteenth-century homes to their former beauty. In addition, neighborhood organizations, working with municipal agencies, have renovated several institutional structures, such as the Wabash YMCA and Eighth Regiment Armory. Despite these favorable developments, the future of Douglas/Grand Boulevard remains uncertain. Will the neighborhood be revitalized as a new Bronzeville, with a lively commercial district and beautified residential areas, or will it remain an impoverished, inner-city neighborhood? The only certainty is that future of Douglas/Grand Boulevard will be as contested as its past.

One

EARLY SETTLEMENT

The first known people to inhabit the place we call Douglas/Grand Boulevard were Miami Indians, who were living throughout northern Illinois when French explorers Jacques Marquette and Louis Joliet arrived at the Chicago Portage in 1673. Around 1700, the Miami were displaced by Potawatomi Indians from southwestern Michigan, who came for the lucrative fur trade, then under French control. The Potawatomis remained until the early 1830s, when the U.S. government forced them to sell their lands and move west of the Mississippi River. Today, Vincennes Avenue, formerly called the *Vincennes Trace*, serves as a reminder of American Indian presence. An ancient trail, it once led to outlying villages and hunting grounds, reaching nearly 200 miles south to Fort Vincennes, a French outpost on the lower Wabash River.

During the early 1800s, the trail became an important route for settlers and farmers bringing their goods to market; by then, it was called Hubbard's Trail after Gurdon S. Hubbard, an American fur trapper and early resident. Except for a few scattered sites, however, the future site of Douglas/Grand Boulevard remained unsettled until the 1850s, when Illinois's Democratic Senator, Stephen A. Douglas, purchased a large tract of land for investment purposes. Subsequently, the Illinois Central Railroad, whose tracks form the neighborhood's eastern boundary, Chicago University, and Camp Douglas spurred some development, but real growth did not occur until after the Great Fire of 1871 when many Chicagoans who had lost their homes moved south of the central city.

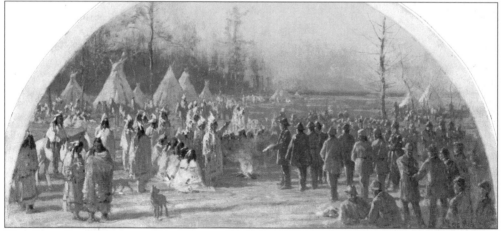

THE LAST COUNCIL OF THE POTAWATOMIS, 1833, BY LAWRENCE C. EARLE, 1900. In late August 1833, more than six thousand Potawatomi, Chippewa, and Ottawa Indians gathered in Chicago to negotiate a treaty ceding their lands west of Lake Michigan to the U.S. government in exchange for a million dollars and western reservations. The future site of Douglas/Grand Boulevard had been relinquished previously by the Treaty of Greenville (1795) and a subsequent treaty in 1821.

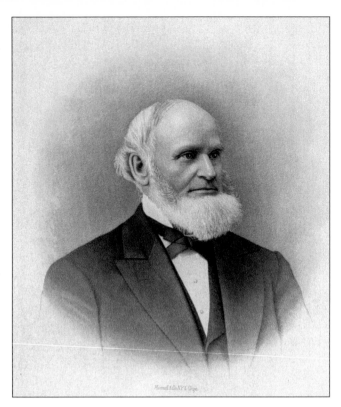

WILLARD F. MYRICK, C. 1860. Originally from Vermont, the enterprising Willard F. Myrick moved to Chicago in 1836, and purchased property 3 miles south of the city at the present site of Michael Reese Hospital. Here, he opened a hotel and the city's first livestock pens for drovers bringing their cattle to market. Adding to his venture in 1844, Myrick built Chicago's first racetrack between Twenty-sixth and Thirty-first Streets, east of Indiana Avenue.

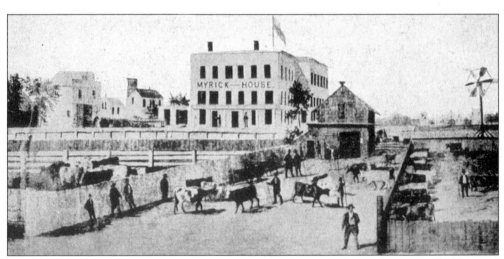

MYRICK HOUSE AND LIVESTOCK YARDS, C. 1860. This view of Myrick's was probably made from the tracks of the Illinois Central Railroad, lying one block to the east. John B. Sherman purchased Myrick's in 1856, and operated it until 1865, when he opened the Union Stock Yard, which consolidated several smaller yards scattered across the city into one giant operation.

STEPHEN A. DOUGLAS, C. 1860. The Douglas neighborhood is named after Illinois's Democratic Senator Stephen A. Douglas (1813–61). One of America's most prominent politicians, he was known as the "Little Giant." Shortly after passing a bill that created the Illinois Central Railroad (1851), Douglas purchased 70 acres of land between Thirty-first and Thirty-fifth Streets, which he called Oakenwald. After selling part to the Illinois Central for its line into the city, Douglas set aside Groveland and Woodland as private residential parks.

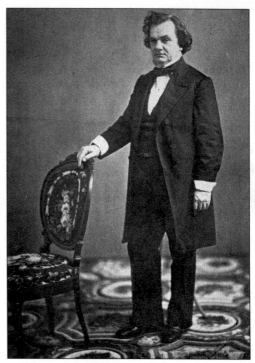

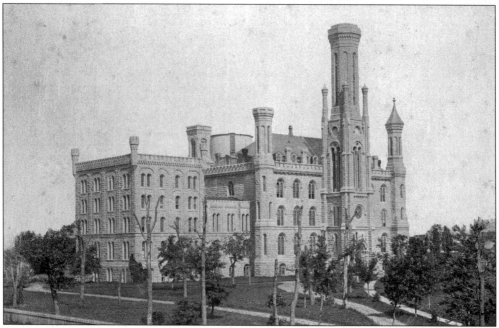

CHICAGO UNIVERSITY, C. 1870. To encourage development, Douglas took up residence on Thirty-fifth Street and donated 10 acres of land to the Baptist Church for Chicago University. Located on Cottage Grove Avenue between Thirty-fourth and Thirty-fifth Streets, the school opened in 1858 in this handsome building designed by W.W. Boyington. Financial difficulties forced the school to close in 1886, but four years later, supporters established the University of Chicago in Hyde Park.

11

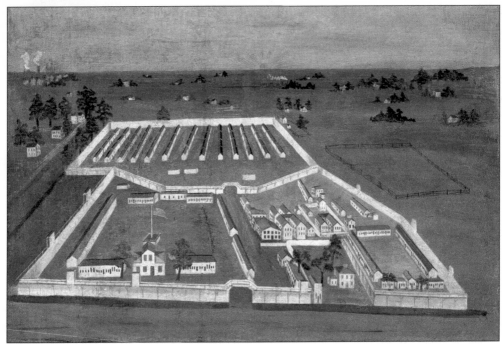

VIEW OF CAMP DOUGLAS, CHICAGO, BY ALBERT E. MYERS, 1862. Constructed on land donated by the estate of Stephen A. Douglas (who died in Chicago on June 3, 1861), Camp Douglas trained over 25,000 Union soldiers during the early years of the Civil War before becoming a detention center for Confederate prisoners of war in 1862. It was located on Cottage Grove Avenue, between Thirty-first and Thirty-third Streets. This naïve painting of the camp is by a Pennsylvania private stationed in Chicago during the war.

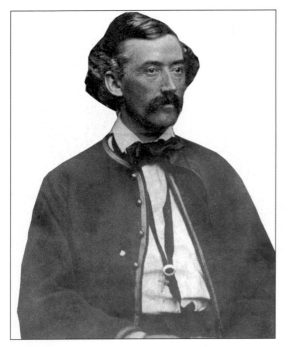

COLONEL JAMES A. MULLIGAN, 1862. One of the Civil War's most popular heroes, Colonel James A. Mulligan of Chicago (1830–64) commanded Camp Douglas between March and June 1862, re-organizing the Twenty-third Illinois Infantry, better known as the Irish Brigade. On July 23, 1864, Mulligan was fatally wounded at the Battle of Kernston, near Winchester, Virginia; his orders to "Lay Me Down and Save the Flag," resounded across the North. Mulligan is buried in Mount Cavalry Cemetery on Chicago's North Side.

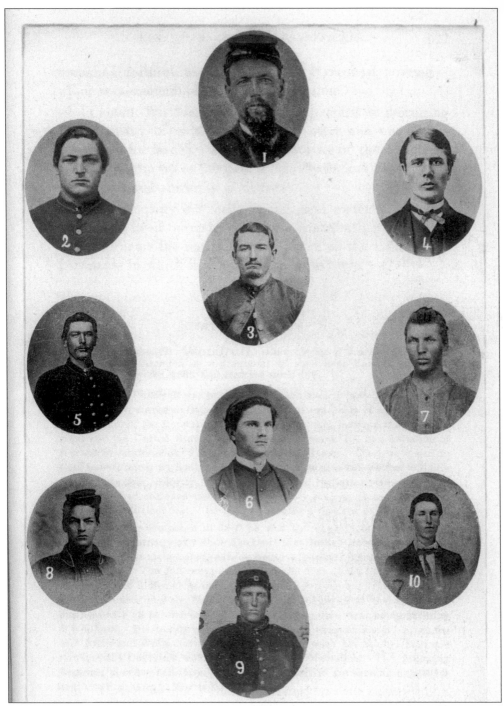

UNION SOLDIERS FROM CAMP DOUGLAS, C. 1861. Numerous regiments from Chicago and northern Illinois trained at Camp Douglas, including the 39th Illinois Volunteer Infantry, whose casualty rate exceeded that of any other state unit. All ten of these men from Company K died in battle or from their wounds, except for William G. Kirkman (#4), who was killed by ex-Confederates after the war while serving with the Freedman's Bureau in Texas.

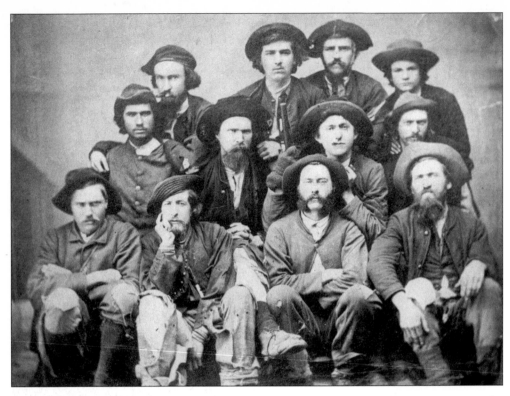

CONFEDERATE PRISONERS AT CAMP DOUGLAS, 1864. Between 1862 and 1865, Camp Douglas housed approximately 30,000 Confederate prisoners of war. The first 9,000 arrived after Ulysses S. Grant's victory at Camp Donelson, TN, in February 1862, and additional prisoners arrived throughout the course of the war. Interred in harsh conditions, prisoners made several unsuccessful attempts to escape, including burrowing out of the camp through underground tunnels. By war's end, 6,000 men had died from deprivation and disease, including small pox. During the war, they were buried in the municipal cemetery (now the southern end of Lincoln Park, but afterwards, the United Confederate Veterans had them re-interred in Oak Woods Cemetery on Sixty-seventh Street. After the war, Camp Douglas was dismantled.

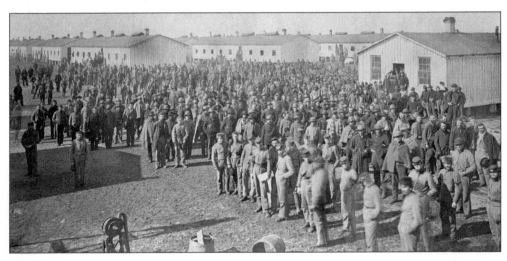

MARY A. LIVERMORE, C. 1865. During the Civil War, Mary A. Livermore of Chicago (1820–1915) worked tirelessly for the U.S. Sanitary Commission, a relief organization for Union soldiers and their families. In 1863 and 1865, Livermore and her associates staged two Sanitary fairs that raised over $325,000 for various causes, including a home for disabled soldiers. Initial funding came from selling lithograph copies of the original Emancipation Proclamation donated by Abraham Lincoln to the 1863 fair.

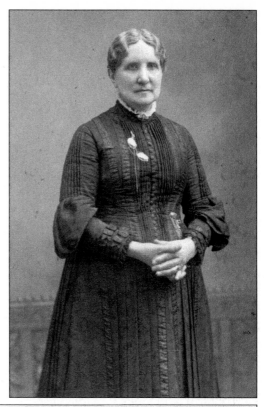

CHICAGO SOLDIERS' HOME, THIRTY-FIFTH AND LAKE PARK AVENUE, 1866. Built with funds from the Sanitary Fairs, the Soldiers' home opened one wing in 1864, and completed the rest of its construction two years later. Before closing in 1870, the home had cared for nearly seven hundred soldiers wounded in the Civil War. The Sisters of Carondelet re-opened the building as an orphanage in 1872, and currently use it as a home for handicapped children.

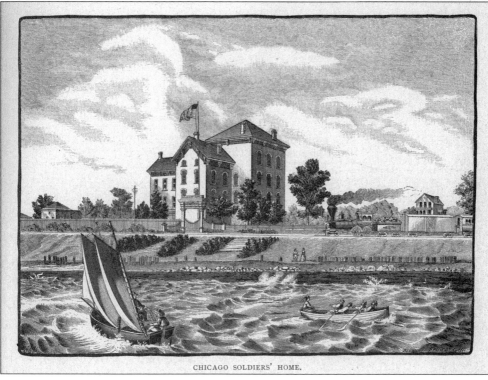

CHICAGO SOLDIERS' HOME.

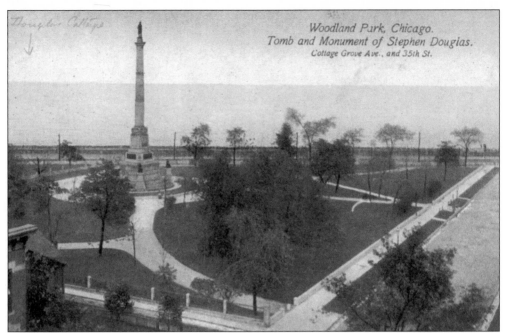

Woodland Park, Chicago.
Tomb and Monument of Stephen Douglas.
Cottage Grove Ave., and 35th St.

STEPHEN A. DOUGLAS MEMORIAL, THIRTY-FIFTH STREET AND LAKE PARK AVENUE. Designed by Leonard Wells Volk and completed in 1881, this monument pays tribute to Illinois's "Little Giant," who died in Chicago on June 3, 1861. Its 46-foot-tall granite column supports a 9-foot bronze figure of Douglas overlooking Lake Michigan. Inside, Douglas's marble sarcophagus is inscribed with his last words: "Tell my children to obey the laws and uphold the Constitution."

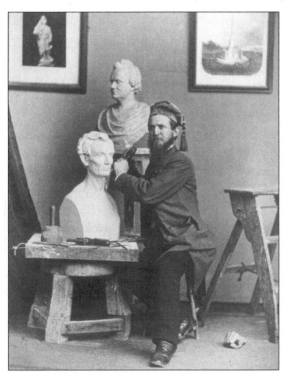

LEONARD WELLS VOLK, C. 1865. Originally from New York, Leonard Wells Volk (1828–95) moved to Chicago in 1857. Related by marriage (Volk's wife was Douglas's cousin), the men became close personal friends as well, with Douglas acting as Volk's patron while the artist established himself. During the 1860 presidential campaign, Volk became well known for his portraits of Douglas's chief opponent, Abraham Lincoln.

16

Two
A City Neighborhood

Between the 1870s and the 1890s, Douglas and Grand Boulevard became well-established urban neighborhoods. Lying closer to the city between Twenty-sixth and Thirty-ninth Streets, Douglas developed first, growing as the city as expanded southward after the Great Chicago Fire of 1871. By 1880, the area included a diverse mix of Anglo-Protestants, German Jews, Irish Catholics, and a growing number of African Americans. Each group established their own institutions, including churches, synagogues, schools, and hospitals. Further south, and outside the city limits until 1889, the Grand Boulevard neighborhood between Thirty-ninth and Fifty-first Streets experienced its greatest period of growth during the 1890s. It became a predominately white, middle and upper-middle-class residential district, with a small African-American community. In keeping with the general southward drift of the city, many Grand Boulevard residents had previously lived in Douglas. Good transportation was key to both neighborhoods; cable cars, commuter trains, and elevated trains provided ready access to the Loop and stimulated commercial development along State Street and Cottage Grove Avenue. By the time of World War I, both Douglas and Grand Boulevards had reached maturity and stood on the brink of major changes that would affect the entire city.

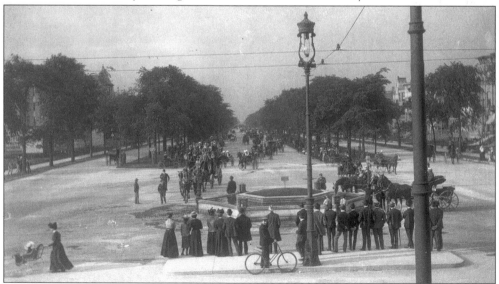

VIEW OF GRAND BOULEVARD, LOOKING SOUTH FROM THIRTY-FIFTH STREET, 1894. Running between Thirty-fifth and Fifty-first Streets, Grand Boulevard has been one of Chicago's major thoroughfares for more than a century. Originally designed as a double-lane carriageway in 1869 by Frederick Law Olmsted, Grand Boulevard accommodated horse, foot, and bicycle traffic before automobiles appeared in the early 1900s.

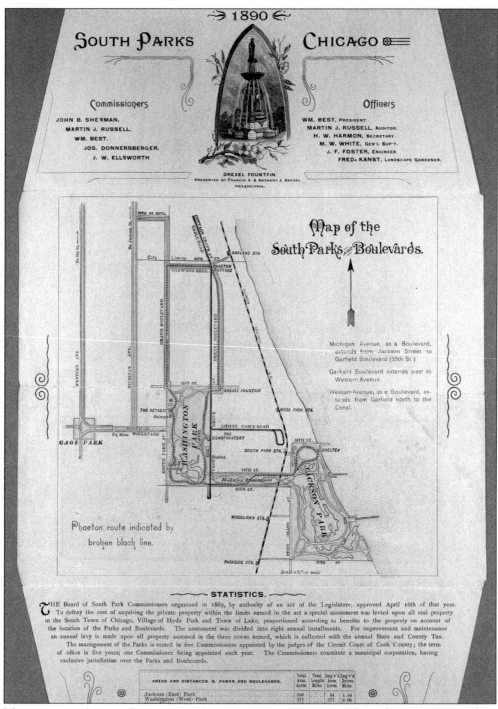

MAP OF THE SOUTH PARKS AND BOULEVARDS, 1890. Grand Boulevard is part of an interlocking system of avenues and parks designed by the noted landscape architect, Frederick Law Olmsted, in 1869 for Hyde Park, then a separate town. Attractive and convenient, the area developed into an upper-middle-class residential district during the 1880s, becoming an official part of the city shortly before the 1893 World's Columbian Exposition.

18

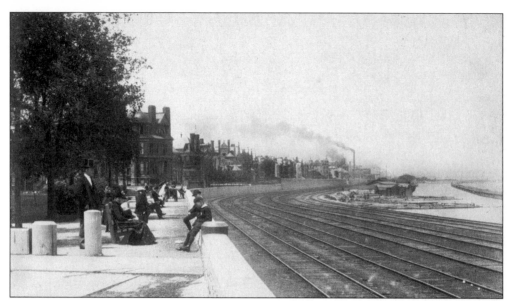

THIRTY-FIFTH STREET LOOKING NORTH, C. 1890. Good transportation was key to developing the city's South Side. As seen in the previous map, the tracks of the Illinois Central Railroad ran along the lakefront, forming the eastern boundary of Douglas/Grand Boulevard. In addition to Thirty-fifth Street, commuter trains stopped at Twenty-seventh, Thirty-first, Thirty-ninth, Forty-third, and Forty-seventh Streets.

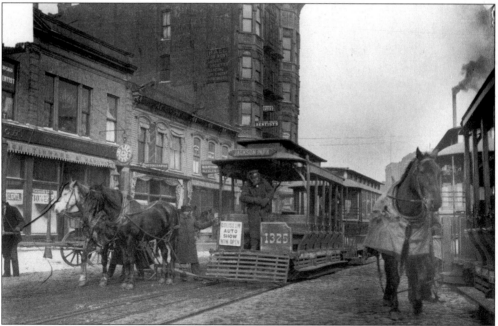

CABLE CAR AT 3910 COTTAGE GROVE AVENUE, 1903. Although they frequently broke down, cable cars were an important form of transportation in Douglas/Grand Boulevard. They operated along Cottage Grove Avenue from the 1880s through the early 1920s, attracting businesses like Herman Hirsch's Tinware & Hardware, John L. Dodge Photographs, and several doctors and dentists. Note that the trains' front cars have windows for first-class passengers.

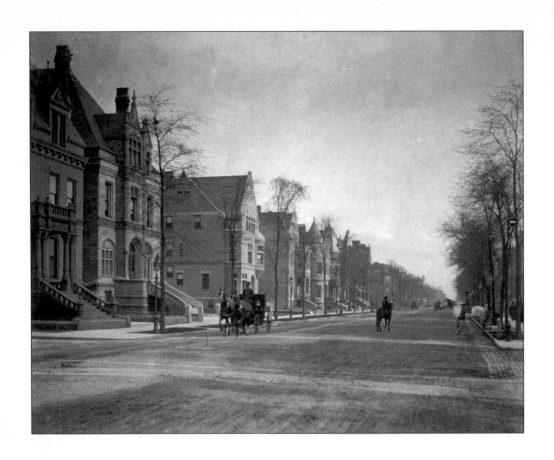

(ABOVE) MICHIGAN BOULEVARD, C. 1893. (BELOW) GRAND BOULEVARD, C. 1893. Taken around the time of the World's Columbian Exposition, these photographs capture the grace and charm of a by-gone era. Although time and the wrecking ball have taken their toll, many fine old homes still stand along Michigan and Grand Boulevard, linking current residents to the neighborhood's past.

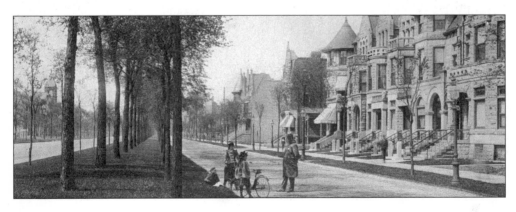

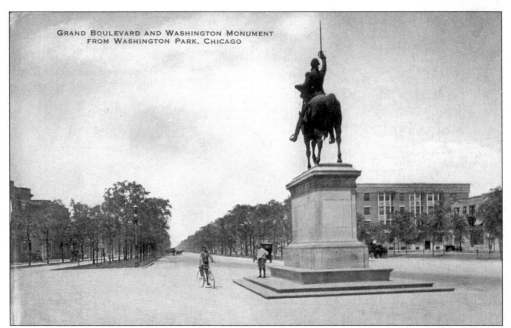

GRAND BOULEVARD LOOKING NORTH FROM WASHINGTON MONUMENT, C. 1895. An equestrian statue of George Washington guards the Fifty-first Street entrance to Washington Park. Erected in 1904, the heroic bronze figure was designed by the well-known American artist, Daniel Chester French. It replicates another statue he made for the city of Paris to commemorate France's role in the American Revolution.

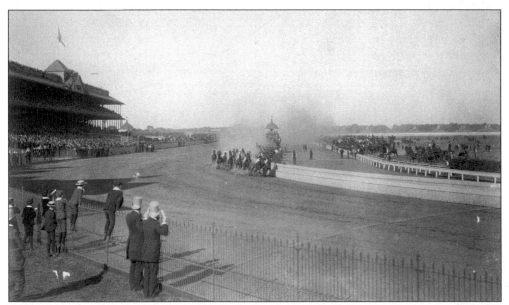

AMERICAN DERBY DAY, WASHINGTON PARK RACE TRACK, C. 1900. After opening in 1884, Washington Park Race Track attracted large crowds for nearly two decades. Chicago's elite considered its first race of the season, the American Derby, to be *the* social event of the year. They rode in elegant carriages to the track, forming a fashionable promenade along Grand Boulevard. The track closed in 1905 for gambling-related problems.

(BELOW) THE CHARLES W. BREGA RESIDENCE, 2816 MICHIGAN AVENUE; (BOTTOM RIGHT) THE GEORGE MIDDLETON RESIDENCE, 3322 MICHIGAN AVENUE; AND (CENTER) THE EDWIN PARDRIDGE RESIDENCE, 2808 PRAIRIE AVENUE. As envisioned by Stephen Douglas, many wealthy Chicagoans built palatial homes on the city's South Side during the late nineteenth century. Indeed, Michigan Avenue became known as the "avenue of millionaires," rivaling Prairie Avenue slightly

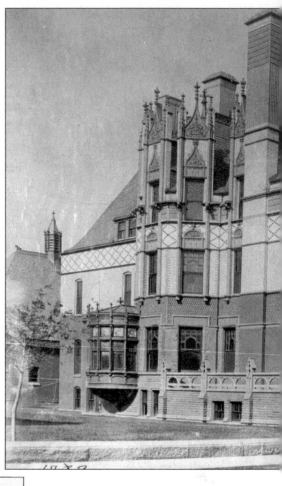

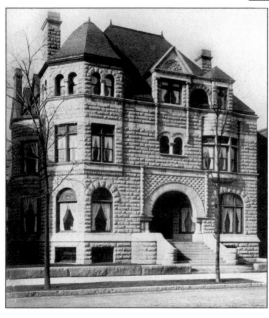

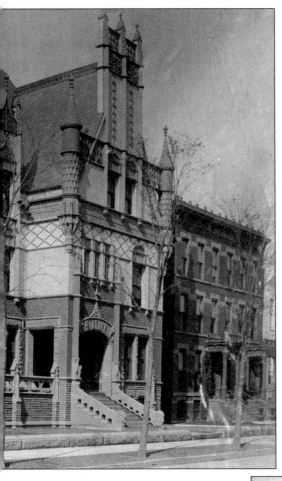

to the north. The homes of Charles Brega, member of the Chicago Board of Trade, Edwin Pardridge, part-owner of the Boston Store, and George Middleton, a Civil War veteran who operated "Wonderland," a dime museum on Clark Street, illustrate how Chicago's upper-class lived. Most of their homes were built in popular revival styles of the late Victorian period, including Italianate, Tudor, Queen Anne, and Romanesque.

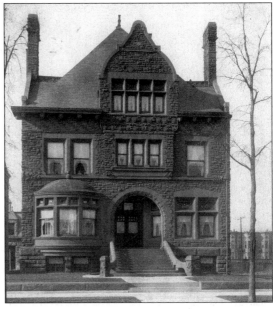

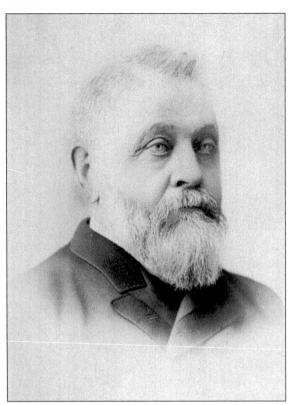

CONRAD SEIPP (LEFT), C. 1885;
CATHARINA SEIPP WITH
DAUGHTERS, ELSA AND CLARA
(BELOW), C. 1885.

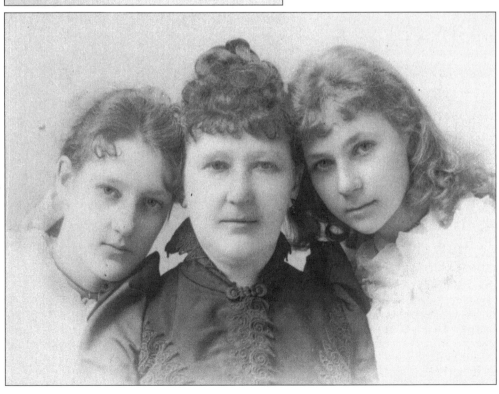

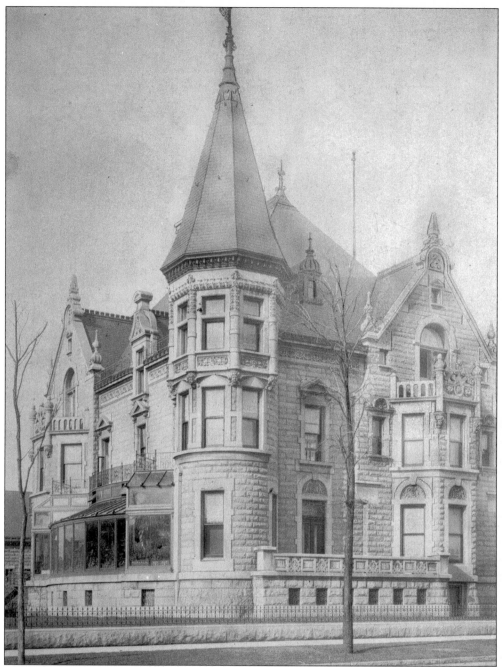

THE SEIPP RESIDENCE, 3300 MICHIGAN AVENUE. One of the grandest homes on Michigan Avenue belonged to Conrad Seipp, wealthy owner of Seipp Brewing Company. Both Conrad and his wife, Catharina, were born in Germany; Conrad immigrated to Chicago in 1848, while Catharina came in 1865. They had six daughters: Marie, Hattie, Emma, Clara, Elsa, and Alma. Among her many civic contributions, Catharnina funded an addition to Grant Hospital in memory of her husband, who died in 1890. Catharina continued to live in this home until her death in 1920 at age 73. The house was demolished in 1933.

**JOHN W. GATES (LEFT), C. 1900;
THE GATES RESIDENCE (BELOW),
2944 MICHIGAN AVENUE.** One of
the few South Side mansions still
standing, this home originally
belonged to Sidney A. Kent,
wealthy member of the Board of
Trade. Designed in 1882 by the
well-known architectural firm of
Burnham and Root, the home
features a carved mahogany staircase
leading to a grand ballroom on the
third floor. John W. Gates, founder
of the American Steel and Wire
Company, purchased the home in
1897; widely known for taking huge
financial risks, Gates earned the
nickname "Bet-a-Million" and
entertained his guests lavishly at his
home. Gates lived here with his
family until 1910, when they moved
to the Waldorf-Astoria Hotel in
New York. Afterwards, the home
housed the Catholic Youth
Organization (CYO) and later
became condominiums.

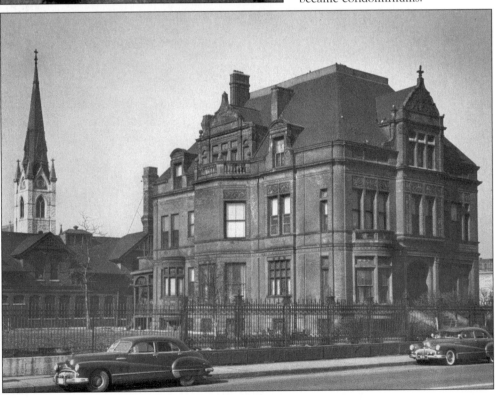

JOHN CUDAHY, C. 1895.

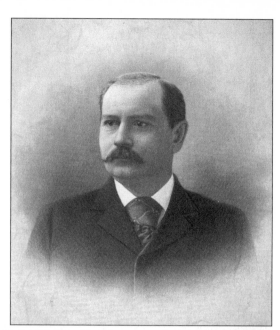

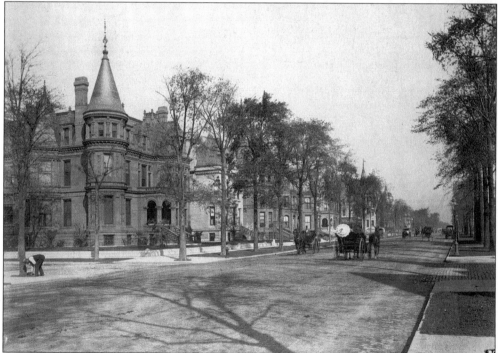

THE CUDAHY RESIDENCE, 3254 MICHIGAN AVENUE. An Irish immigrant who made a fortune in the meat-packing business, John Cudahy lived with his wife Margaret and their children in this elegant stone mansion designed by Burling and Whitehouse in 1886. The peach-brown, 40-room structure had a 40-foot-long reception hall, an ebony staircase leading to a third-floor ballroom with mirrored walls, a mahogany-walled billiard room, and a music gallery in the conical tower. Between 1919 and 1928, the Chicago Motor Club occupied the home; later, graduate students from Armour Institute (now IIT) lived in the home, which no longer stands.

27

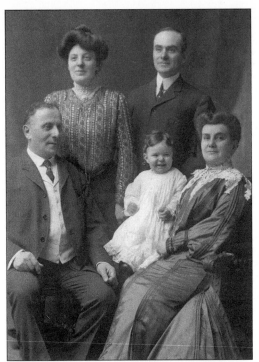

THE MANDEL FAMILY (LEFT), C. 1900; THE MANDEL RESIDENCE (BELOW), 3400 MICHIGAN AVENUE. Millionaire vice president of the Mandel Brothers department store, Emanuel Mandel and his wife, Babette, lived in this 30-room mansion designed by L.B. Dixon. Throughout their lives, the Mandels contributed to many charities and institutions, most notably Michael Reese Hospital. After Emanuel died in 1908, Babette remained in their home until World War I, when she donated it to the government to house student-soldiers at Armour Institute. Afterwards, an African-American funeral home occupied the structure for many years; eventually, it became transient housing. The home was gutted by fire and demolished in 1958. In this family portrait are: (clockwise from seated) Emanuel, his daughter-in-law Carrie G. and son Frank E. (who lived nearby at 3341 Michigan Avenue), and Babette, holding her grandson, Frank E. Mandel Jr.

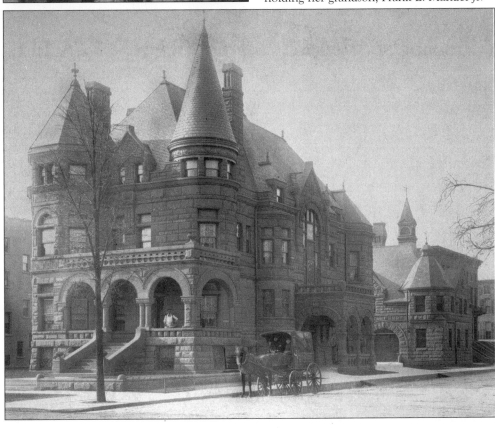

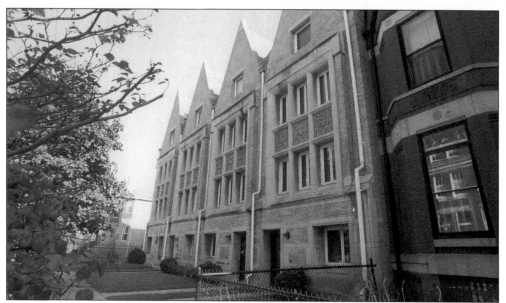

ROBERT W. ROLOSON HOUSES, 3213–19 SOUTH CALUMET AVENUE. Designed by Frank Lloyd Wright, this set of four Tudor-style row houses was commissioned by Robert W. Roloson, a wealthy member of the Chicago Board of Trade and Stock Exchange. Completed in 1894, they pre-date Wright's more famous Prairie-style structures and feature elaborate ornamentation reminiscent of Louis Sullivan, the architect's early employer and mentor. Although the exteriors remain intact, the interiors have been significantly altered.

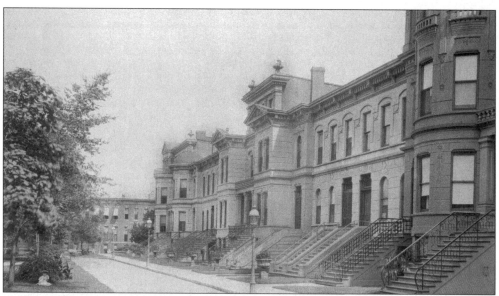

ALDINE SQUARE, 3700–3900 VINCENNES AVENUE, C. 1900. Developed between 1876 and 1895 by Chicago lawyer Uzziel P. Smith, Aldine Square featured three and four-story homes facing a central park. Built for above-middle-class residents, the park began to deteriorate around the time of World War I, when the neighborhood experienced rapid racial change. Renamed DuSable Square in 1936 afte Jean Baptiste Du Sable Chicago's first permanent settler, the park was demolished in 1949 during urban renewal.

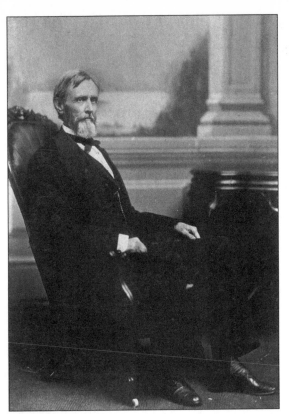

HARLOW N. HIGINBOTHAM (LEFT), C. 1885; THE HIGINBOTHAM RESIDENCE (BELOW), 2838 MICHIGAN AVENUE. One of Chicago's leading citizens, Harlow N. Higinbotham lived with his wife, Rachel, and their children in this luxurious home designed by architect F. Meredith Whitehouse. Originally from Joliet, Higinbotham served as chief clerk to the Ohio Quartermaster during the Civil War; afterwards, he settled in Chicago, where he earned a fortune as partner in Marshall Field & Company. In addition to serving as president of the 1893 World's Columbian Exposition, Higinbotham supported St. Paul's Universalist Church, the Newsboys' Home, and the Home for the Incurables. Higinbotham died in 1910, and his home no longer stands.

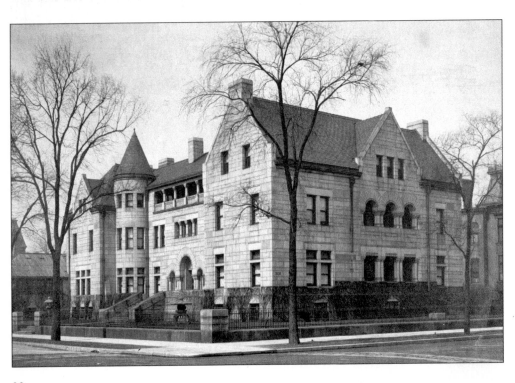

Weekly schedule, St. Paul's Universalist Church (Right), 1891; St. Paul's Universalist Church (Below), Thirtieth Street and Prairie Avenue, 1889. One of Chicago's oldest congregations, St. Paul's moved to this structure in 1888. Its congregation included some of Chicago's wealthiest families, including the George M. Pullmans and Harlow N. Higinbothams. In addition to regular Sunday services, the church supported a free kindergarten and an industrial school for immigrant and African-American children living in the neighborhood. In 1917, St. Paul's relocated to Hyde Park, where most of its members had moved.

St. Paul's Church,
CHICAGO.

NOTICES FOR WEEK

Beginning Jan. 11, 1891.

ALL INVITED.

SUNDAY.

MORNING SERVICE—10:30 a. m.

SUNDAY-SCHOOL—12:15 p. m.

YOUNG PEOPLE'S CHRISTIAN UNION—6:30 p. m.
You are cordially invited to attend these meetings.

EVENING SERVICE—7:30 p. m.
Second Sermon in Evening Course.

MONDAY—8:00 p. m.

PASTOR'S RECEPTION—
By Ladies' Aid Society in Chapel.

WEDNESDAY—8:00 p. m.

MID-WEEK MEETING—
In Chapel.

FRIDAY—10:00 a. m.

LADIES' AID SOCIETY—
Meets in Church Parlors.

SATURDAY—10:00 a. m.

INDUSTRIAL SCHOOL—
In Chapel.

Free Kindergarten Every Forenoon,
Except Saturday.

PASTOR'S THIRD SERMON IN MORNING COURSE,
NEXT SUNDAY MORNING.

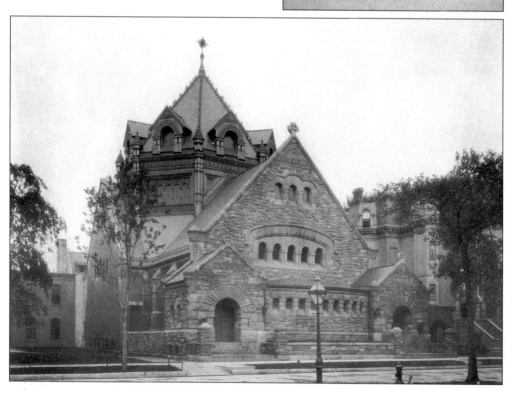

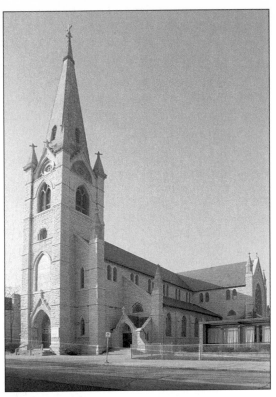

ST. JAMES CATHOLIC CHURCH, 2940 S. WABASH, 2000. Irish immigrants arrived in Douglas during the 1850s. They lived in worker cottages along Federal Street, labored in the nearby car shops of the Illinois Central Railroad, and worshiped at St. James, then a frame church at Twenty-seventh and Prairie Avenue. In 1885, the congregation completed a neo-Gothic structure designed by architect Patrick C. Kelley, who had just completed Holy Name Cathedral.

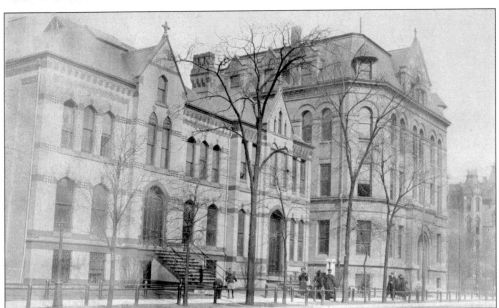

ST. JAMES SCHOOLS, C. 1905. (COURTESY ST. JAMES CHURCH) By 1900, St. James parish included a grade and high school on Wabash Avenue, next door to the church. The Sisters of Mercy staffed both schools, which had a combined enrollment of 1,400 students. Today, St. James continues to operate a grade school at the same location but in a modern, one-story building.

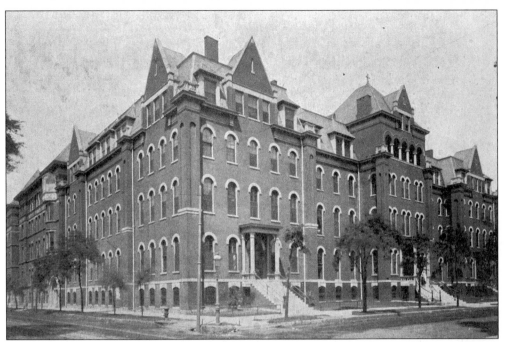

MERCY HOSPITAL, TWENTY-SIXTH STREET AND CALUMET AVENUE, C. 1910. Founded in 1852 by the Sisters of Mercy, Mercy Hospital opened this facility for three hundred patients in 1869. Affiliated with Northwestern University and later with Loyola University, Mercy served as a teaching and research hospital and operated its own nursing school. In the late 1960s, Mercy Hospital demolished this building for a new facility at 2525 South Michigan Avenue.

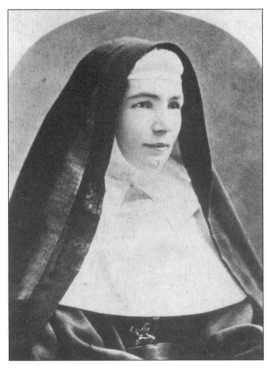

SISTER MARY IGNATIUS FENNEY, C. 1890. (COURTESY SISTERS OF MERCY OF THE AMERICAS, CHICAGO REGIONAL ARCHIVES.) A pioneer in health care and women's education, Sister Fenney was born in Ireland in 1841. She immigrated to Chicago with her parents in 1854, and joined the Sisters of Mercy at age 18. In addition to founding Mercy Hospital's highly respected school of nursing, Sister Fenney was the first woman to pass the Illinois State Board Examination for Pharmacists, achieving that honor in 1881.

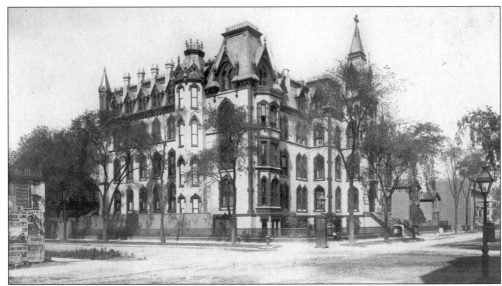

ST. XAVIER ACADEMY, 2834 WABASH AVENUE, C. 1895. (COURTESY SISTERS OF MERCY OF
THE AMERICAS, CHICAGO REGIONAL ARCHIVES.) The Sisters of Mercy originally established
St. Xavier Academy as a convent in 1847. They opened this building in 1873, but moved to an
even larger facility at Forty-ninth Street and Cottage Grove Avenue in 1901. St. Xavier's moved
again in 1954 to Ninety-ninth and Central Park Streets, where it later became a university.

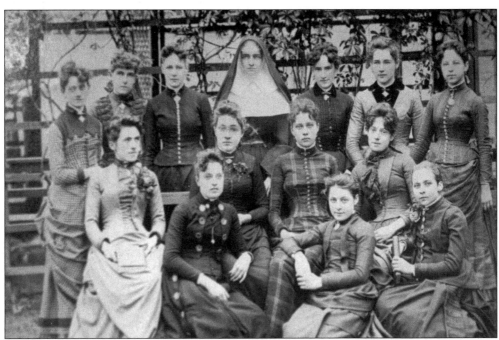

ST. XAVIER ACADEMY STUDENTS, 1888. (COURTESY SISTERS OF MERCY OF THE AMERICAS,
CHICAGO REGIONAL ARCHIVES.) Over the years, thousands of young women from across
Chicago attended St. Xavier's. They received a sound education, including religious instruction
in Roman-Catholic doctrine. By the early 1900s, St. Xavier's included a kindergarten and grade
school to provide for Chicago's growing population of Catholic children.

34

DE LA SALLE INSTITUTE, THIRTY-FIFTH STREET AND WABASH AVENUE, C. 1890. (COURTESY DE LA SALLE INSTITUTE.) Established in 1889 by the Christian Brothers, De La Salle Institute trained young men from Irish working-class families for careers in business as clerks and secretaries. De La Salle established a reputation for academic excellence, and although the original structure was demolished in 1984, the school remains in the neighborhood with a new facility at the same location.

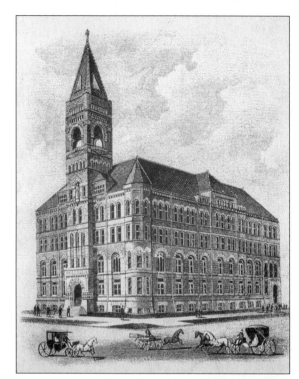

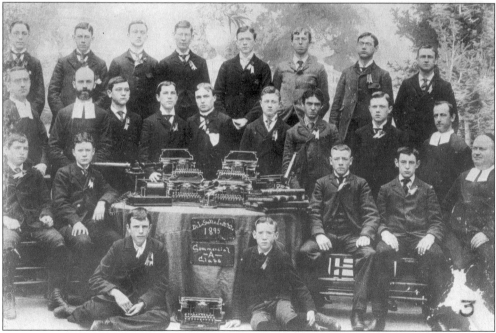

DE LA SALLE INSTITUTE STUDENTS, 1895. (COURTESY DE LA SALLE INSTITUTE.) Seated on the far right-hand side of this photograph is Brother Adjutor, founder of De La Salle Institute. In addition to "commercial" classes that prepared young men to work as clerks and secretaries, De La Salle offered more traditional course work in English, math, and history. No less than five Chicago mayors attended De La Salle, including Richard J. Daley and his son, Richard M. Daley.

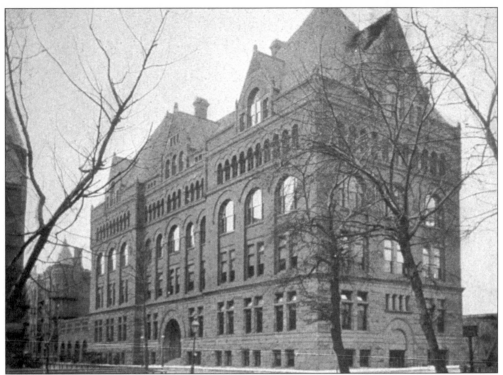

ARMOUR INSTITUTE, THIRTY-THIRD AND FEDERAL STREETS, 1906. Wealthy industrialist Philip D. Armour founded Armour Institute in 1891 primarily as an engineering school for young men. In 1940, Armour Institute merged with Lewis University to form the Illinois Institute of Technology; its main building, designed by Patton and Fisher, still stands.

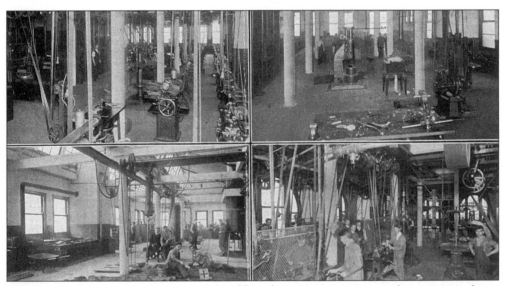

ARMOUR INSTITUTE STUDENTS, 1906. Although engineering remained its primary focus, Armour Institute also trained students in woodworking, photography, math, chemistry, and English. In response to demands from "boys and men who are employed during the day," Armour inaugurated evening classes in 1902 for working students.

OFFICERS OF K.A.M., 1897. Established in the 1840s, *Kehilath Anshe Ma'ariv* ("The Congregation of Men of the West") is the Midwest's oldest Jewish congregation. It's early temples were located downtown, but after the 1871 Chicago Fire, they moved to the South Side, first to a converted church at Twenty-sixth Street and Indiana Avenue and later to a new temple at Thirty-third Street and Indiana Avenue.

K.A.M. SYNAGOGUE, 3301 SOUTH INDIANA AVENUE, 1896. (COURTESY TIMOTHY SAMUELSON) In 1889, K.A.M. commissioned the prestigious Chicago architects Dankmar Adler and Louis Sullivan to design a new temple. Their magnificent structure, completed in 1891, features a Romanesque entry arch inscribed in Hebrew and English: "Open for me the gates of righteousness, that I may enter through them, to praise the Lord." Since 1922, the structure has housed Pilgrim Baptist Church, an African-American congregation.

OFFICERS OF K. A. M., 1897.

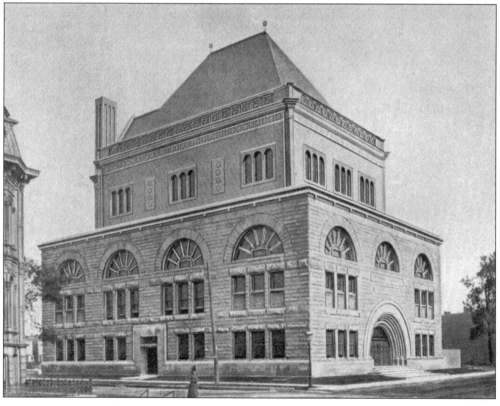

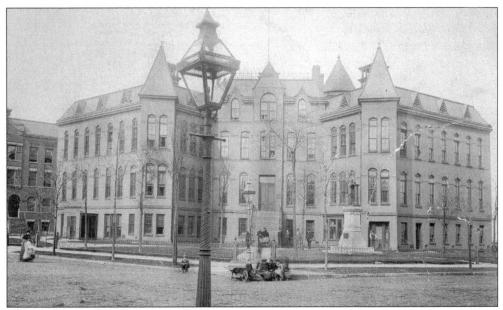

MICHAEL REESE HOSPITAL, C. 1895. Established by Chicago's Jewish community in 1881 as a nonsectarian facility, Michael Reese Hospital became a nationally known teaching and research institution. The original building at Twenty-ninth Street and Cottage Grove Avenue included a nursing school that trained thousands of women for medical careers before closing its doors in 1980. Today, the hospital remains in the neighborhood with more modern facilities at 2929 South Ellis Avenue.

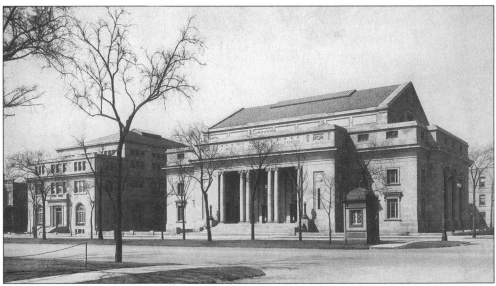

SINAI TEMPLE, FORTY-SIXTH STREET AND GRAND BOULEVARD, 1912. Designed by Chicago architect Alfred S. Alschuler, Sinai Temple housed the oldest Reform Congregation in the world. Originally organized in Chicago in 1861, Sinai moved to Twenty-first Street and Indiana Avenue after the Chicago Fire, but relocated to Grand Boulevard in 1912 and Hyde Park in 1944. Capable of seating more than two thousand people, the structure now houses Mt. Pisgah Baptist Church, an African-American congregation.

EMMA JANE ATKINSON (RIGHT) AND
DR. CLEVELAND HALL (BELOW), C.
1870. By 1890, about ten thousand
African Americans lived in
Douglas/Grand Boulevard. While most
were recent arrivals, some descended
from free blacks and fugitive slaves
who settled in Chicago before the
Civil War. Located near Sixteenth
Street, this early community included
Emma Jane Atkinson and Cleveland
Hall, active members of Chicago's
abolitionist movement; family
tradition holds that Atkinson's home
was a stop on the underground railroad
and harbored fugitive slaves. As the
black community grew, it expanded
southward along State Street, reaching
Douglas by the 1880s. Atkinson lived
at 191 Thirty-first Street, while Hall
lived at 3551 South Dearborn.

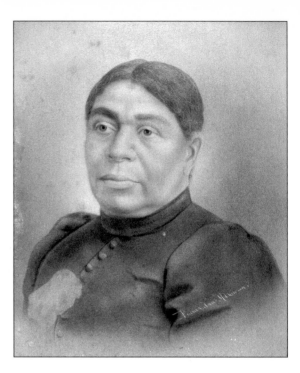

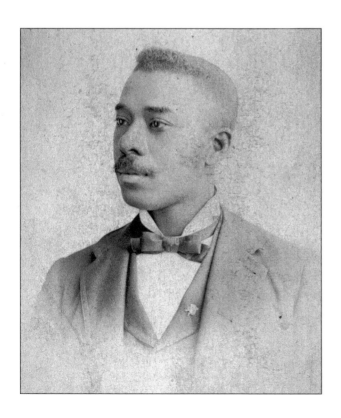

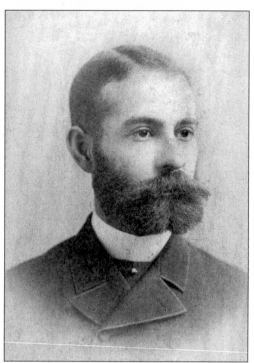

DANIEL HALE WILLIAMS, C. 1900. One of America's first black surgeons, Daniel Hale Williams (1856–1931) helped establish Provident Hospital in 1891 as a biracial institution where black and white doctors and nurses served Chicago's growing black community denied access to white institutions. In 1893, Williams achieved international fame by suturing a man's wounded heart, and he remained on the staff of Provident Hospital until 1913.

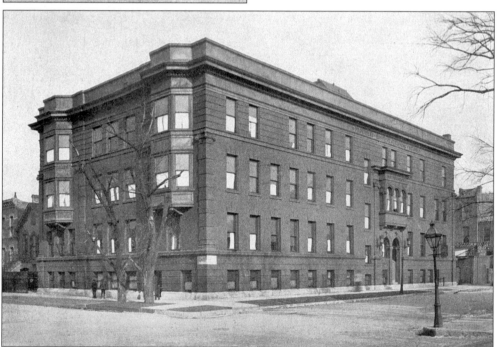

PROVIDENT HOSPITAL, THIRTY-SIXTH AND DEARBORN STREETS, C. 1900. In addition to providing medical care for African Americans, Provident Hospital also trained black doctors and nurses denied access to white institutions. In 1933, Provident moved to 426 East Fifty-first Street; financial difficulties forced its closing in 1987, but the hospital re-opened as Provident Hospital of Cook County at 500 East Fifty-first Street.

THE REVEREND AND MRS. REVERDY CASSIUS RANSOM, C. 1900. Originally from Ohio, Reverdy Ransom (1861–1959) moved to Chicago in 1896 to become minister of Bethel African Methodist Episcopal Church. In 1900, with the help of noted social activists Jane Addams and Clarence Darrow, Ransom established the Institutional Church and Social Settlement, Chicago's first settlement house for African Americans.

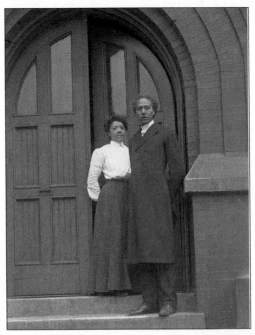

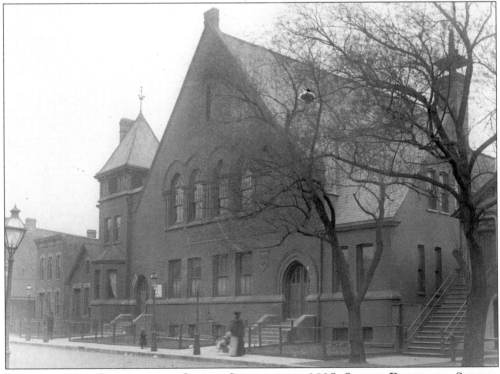

INSTITUTIONAL CHURCH AND SOCIAL SETTLEMENT, 3825 SOUTH DEARBORN STREET, 1903. In addition to religious services, Reverend Ransom's Institutional Church provided its members with a kindergarten, employment bureau, cooking classes, public lectures, and a fully equipped gymnasium. The institution thrived until the time of World War I, when secular agencies assumed most of its social functions. The building no longer stands.

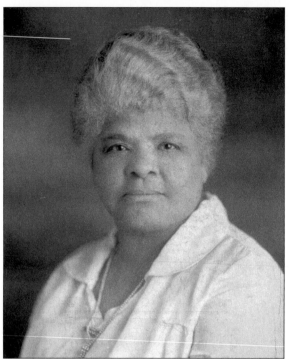

IDA BELL WELLS-BARNETT, 1930.
The nationally renowned civil rights activist Ida B. Wells-Barnett (1862–1931) lived with her family at 3624 Grand Boulevard from 1919 to 1929. Wells originally came to Chicago in 1893 to protest the exclusion of African Americans from the Chicago World's Fair; she later campaigned against the lynching of Southern blacks.

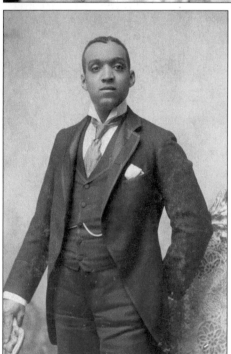

ANDREW C. AND VALETTA WINSLOW DRISDEN, 4528 ST. LAWRENCE STREET. Compared to Ida B. Wells, Andrew and Valetta Drisden are little known, yet they and others whose photographs appear on the next several pages provide a glimpse into the early African-American community of Douglas/Grand Boulevard.

GABRELLA KNIGHTEN SMITH, DRESSMAKER, 2811
SOUTH STATE STREET.

LLOYD GARRISON WHEELER (LEFT), TAILOR, 4440 SOUTH LANGLEY STREET; AND AGNES
BERRY MOODY (RIGHT), 3604 SOUTH DEARBORN STREET.

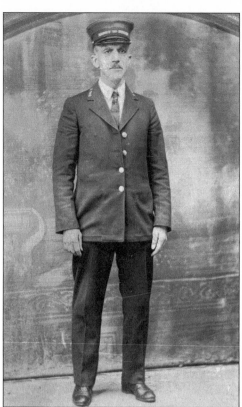

JOSEPH HUDLUN, TELEPHONE OPERATOR, 115 WEST FIFTY-FIRST STREET.

ANNA ELIZABETH HUDLUN (LEFT); AND KITTY HUDLUN (RIGHT), 115 WEST FIFTY-FIRST STREET.

HIAWATHA W. RHEA, 1908. During the early 1900s, Hiawatha W. Rhea published a directory of black-owned businesses in Chicago, listing barbers, lawyers, physicians, restaurants, saloons, undertakers, and many other establishments. Rhea's directory also included black-owned businesses in the suburbs, New York, and several southern states.

The J. T. H. Woods
Hardware Company
3636 State Street, . . . Chicago, Ill.
Telephone Douglas 1613.

Dealers In All Kinds of

Cooking Utensils, Builders' and Carpenters' Tools, Notions and Novelties.

First and only Hardware Store, Owned and Operated by Colored People, any where in the County.

ADVERTISEMENT FROM RHEA'S DIRECTORY, 1908. As seen in Rhea's directory, Douglas/Grand Boulevard had dozens of black-owned businesses before World War I. Many were located along State Street, including the J.T.H. Woods Hardware Company, which claimed to be the "first and only" black-owned and operated hardware store in the country.

45

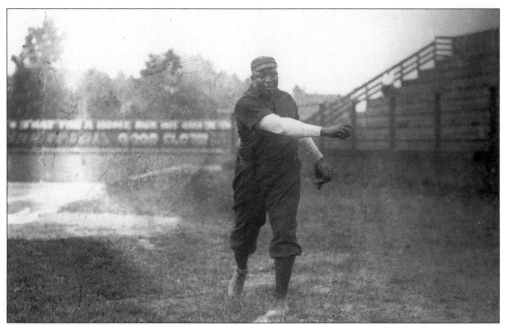

ANDREW "RUBE" FOSTER, 1909. Denied access to major league baseball until 1945, African Americans formed their own teams. In Chicago, ace pitcher Andrew "Rube" Foster (1879–1930) played for the Leland Giants and later the American Giants. He helped organize the Negro National Baseball League in 1920, and served as its president. Originally from Texas, Foster lived in the Grand Boulevard district at 4131 South Michigan Boulevard until his death.

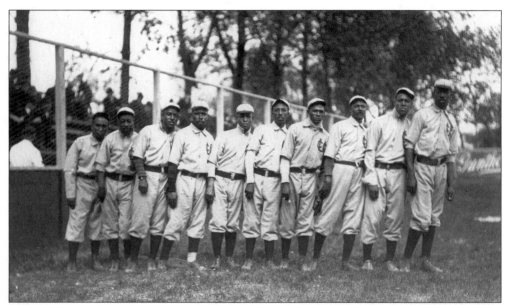

UNION GIANTS, 1905. Established in 1901, the Union Giants competed in the Chicago Baseball League, which included white as well as black teams. Like other black teams, the Giants also played against professional and semiprofessional teams across the country. In 1905, they won 112 of 122 games. From left to right are as follows: Bill Irwin, Willis Jones, P. Roberts, Haywood Rose, Tom Washington, Harry Hyde, Clarence Lytle, George Hopkins, George Johnson, and George Taylor.

JACK JOHNSON, 1912.

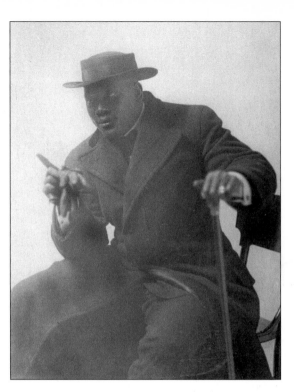

JACK JOHNSON RESIDENCE, 3344 SOUTH WABASH AVENUE, C. 1915. One of the greatest boxers in American history, Jack Johnson (1878–1946) became the first African-American heavyweight champion of the world in 1910. With his earnings, Johnson purchased a home on the South Side and opened the Café de Champion at 42 West Thirty-first Street. Convicted in 1912 for violating the Mann Act (transporting a woman for immoral purposes across state lines), Jackson jumped bail and spent nearly eight years living abroad before serving a ten-month prison term in the United States. After dying in an automobile accident in North Carolina, Johnson was buried in Chicago's Graceland Cemetery.

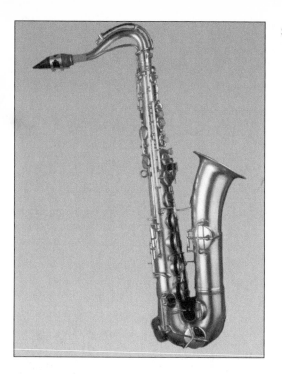

SAXOPHONE USED BY JAMES PALAO, C. 1915.

THE ORIGINAL CREOLE ORCHESTRA, C. 1915. (COURTESY CLOTILE PALAO WILSON.) Born in New Orleans, jazz moved north to Chicago with legendary musicians like King Oliver, Jelly Roll Morton, and Louis Armstrong. Lesser known was James Palao, who led the Original Creole Orchestra, one of the first jazz bands to play in Chicago. The band included, from left to right: (front row) Dink Johnson, James Palao, Norwood Williams; (back row): Eddie Vinson, Freddie Keppard, George Baquet, and Bill Johnson. During the 1920s, white musicians, including Jimmy McPartland and Benny Goodman from the city's West Side, frequented South Side clubs and later helped introduce jazz to white audiences.

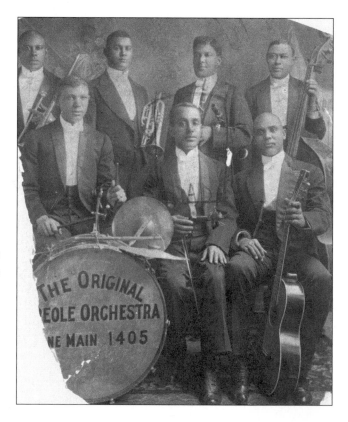

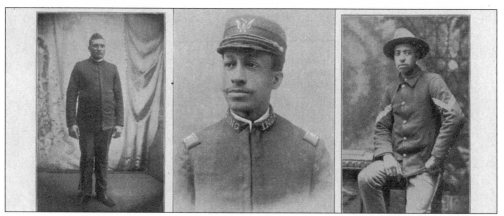

OFFICERS OF THE EIGHTH ILLINOIS UNITED STATES VOLUNTEERS, 1899. Left to right: Lt. John W. Allison, Cptn. Theodore Van Pelt, Lt. Stewart Betts. Organized during the Spanish-American War (1898) as the nation's only black regiment commanded by African Americans, the Eighth Illinois Volunteers had its headquarters in Chicago. Many of its officers lived and worked in Douglas/Grand Boulevard; Captain Theodore R. Van Pelt, for example, owned a barbershop at 2903 Dearborn Street and lived on the next block.

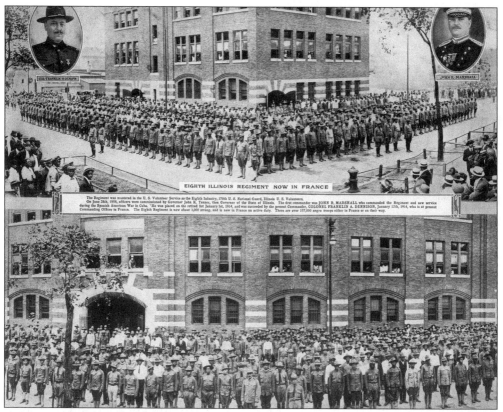

EIGHTH ILLINOIS REGIMENT AND ARMORY, 1918. During World War I, the Eighth Regiment served in France as the 370th Infantry of the 93rd Division with about three thousand men under Colonel Franklin A. Dennison. Their armory, located at 3533 Giles Avenue, was completed in 1915; recently renovated, it currently houses the Chicago Military Academy of Bronzeville.

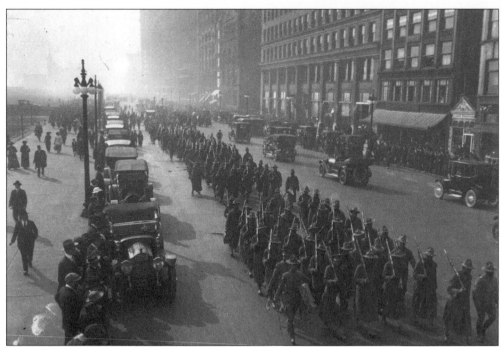

EIGHTH ILLINOIS REGIMENT ON PARADE, FEBRUARY 17, 1919. Engaged in heavy action during World War I, the "Fighting Eighth" received numerous citations from the French and American governments, including 22 distinguished service medals. When they returned from active duty, Chicago honored them with a parade along Michigan Avenue attended by city officials and thousands of spectators.

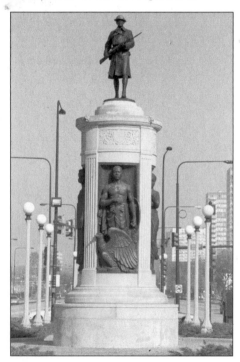

VICTORY, THIRTY-FIFTH STREET AND KING DRIVE. After World War I, Chicago's African Americans lobbied the State of Illinois for a memorial honoring the Eighth Illinois Regiment. Designed by Leonard Crunelle and finally erected in 1927, *Victory* features a bronze relief panel with names of soldiers who died in France, three heroic figures cast by American Art Bronze Foundry of Chicago, and an African-American doughboy added in 1936.

Three

BRONZEVILLE

During World War I, a booming economy and tight labor market launched the Great Migration of African Americans from southern states to the North. Between 1916 and 1920, more than 50,000 blacks came to Chicago to work in the city's meatpacking, rail, and steel industries. Most settled in Douglas/Grand Boulevard, where a small community of blacks had lived for generations. One of the most significant events in American history, the Great Migration created racial tension and conflict in a city dominated by whites. In 1919, tensions erupted in a tragic race riot on the South Side that left dozens dead. Afterwards, white residents began moving away in ever-greater numbers, and, by 1925, Douglas/Grand Boulevard had become nearly 90 percent black. Despite the harmful effects of segregation, Douglas/Grand Boulevard flourished with hundreds of African-American-owned-and-operated businesses, social organizations, and cultural institutions. Indeed, the neighborhood became a national model of African-American achievement, but the Great Depression proved devastating, as the community had few resources to withstand the worst economic collapse in American history. Unemployment rates soared, and, by 1934, over 50 percent of all families in Douglas/Grand Boulevard were living on government relief. The neighborhood began to recover under President Franklin D. Roosevelt's New Deal and experienced an upswing during World War II, when busy factories once again employed local residents and beckoned an additional 60,000 southern blacks northward. Denied access elsewhere, they crowded into Douglas/Grand Boulevard and the West Side, setting the stage for the massive urban renewal projects of the 1950s.

CENTRAL STATION. Portal of the Great Migration, the Illinois Central Railroad's main station stood at 135 East Eleventh Place, about 2 miles north of Douglas/Grand Boulevard. Between 1916 and 1920, it received over 50,000 African Americans and another 60,000 during World War II. Although bound for freedom, blacks rode in segregated cars until the mid-1950s.

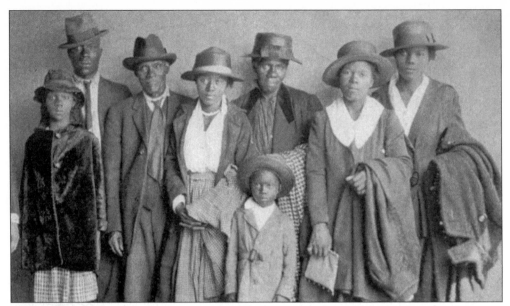

AFRICAN-AMERICAN MIGRANTS, C. 1920. The largest number of African-American migrants came from Mississippi, Alabama, Tennessee, and Georgia. Although some had lived in smaller cities like Nashville, most migrants came from rural areas, where they had worked as sharecroppers for generations. As newcomers, they faced racial prejudice from white Chicagoans and class bias from many "old settlers" in the black community, who considered them naïve country folk.

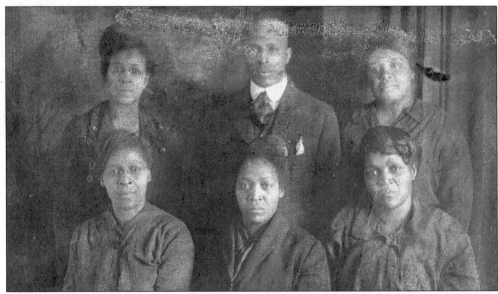

THE MCCONNER FAMILY, C. 1920. (COURTESY TIMUEL D. BLACK.) The McConner family migrated from Birmingham, Alabama, to Chicago around World War I. Although Walter (center, back row) moved to Detroit, his sisters settled in the Grand Boulevard–Washington Park area, where descendants lived through World War II. From left to right are as follows: (front row) Mary Moore, Mattie Black, and Emma Ware; (back row) Lucille Wilcher, Walter McConner, and Georgia Meadows.

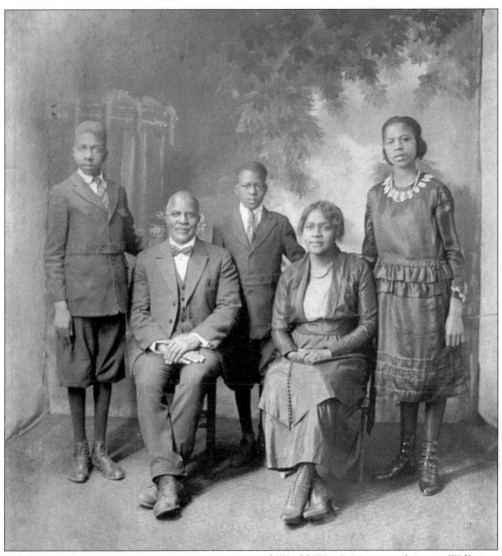

THE MORRIS WILLIAMS FAMILY, C. 1920. Around World War I, Morris and Annie Williams, together with their children Morris Jr., Levi, and Willa Lou, left rural Texas for Omaha, Nebraska, then moved to Chicago, where Morris's brother, the well-known Lacey K. Williams, served as pastor of Olivet Baptist Church. A self-employed entrepreneur, Morris operated a restaurant at 427 East Thirty-first Street, and lived with his family at 3143 Giles Avenue.

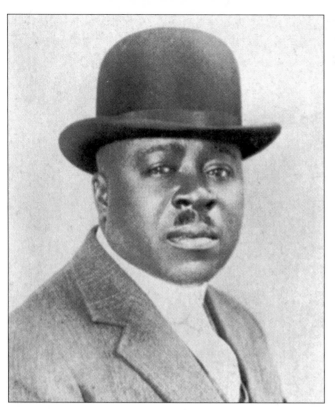

ROBERT S. ABBOTT, 1924.
Founding editor of the
Chicago Defender, Robert
Sengstacke Abbott
(1868–1940) played a key role
in the Great Migration.
Originally from Georgia,
Abbott learned the printing
trade at Hampton Institute in
Virginia before moving to
Chicago in the early 1890s.
After studying law at Kent
College, Abbott launched the
Defender in 1905, and
encouraged its many southern
readers to move north for
better employment
opportunities and living
conditions.

**CHICAGO DEFENDER
OFFICES, 3435 SOUTH
INDIANA AVENUE,
1923.** By the mid-
1920s, the *Chicago
Defender* had more
than two hundred
thousand paid
subscribers and over
one million readers.
Its motto, "The
World's Greatest
Newspaper," can be
seen on the side of its
headquarters, formerly
a Jewish synagogue.
Today, the *Defender*,
the nation's longest-
running African-
American daily
newspaper, is located
at 2400 South
Michigan Avenue.

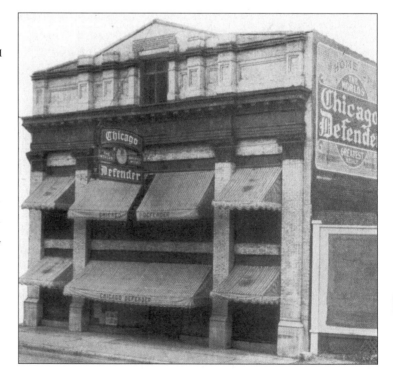

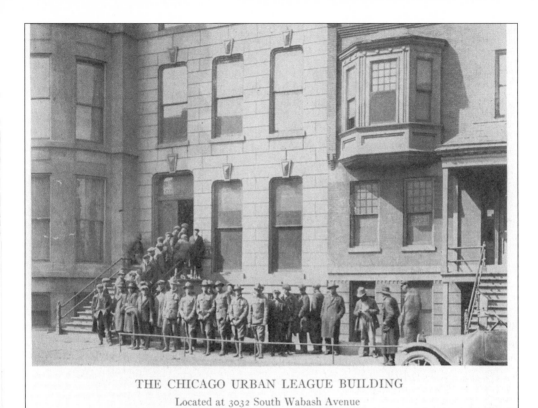

THE CHICAGO URBAN LEAGUE BUILDING
Located at 3032 South Wabash Avenue

THE CHICAGO URBAN LEAGUE, 3032 SOUTH WABASH AVENUE. Established in 1916, the Chicago Urban League helped thousands of African Americans during the Great Migration. In addition to greeting newcomers at Central Station, the organization offered a fully array of social services, including assistance with housing, employment, health care, and education. Today, the organization continues to sponsor many important programs for African Americans in Chicago.

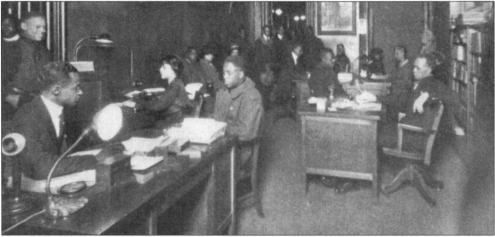

JOB SEEKERS AT THE CHICAGO URBAN LEAGUE, 1920. Chicago's largest employment agency for African Americans, the Urban League played a crucial role in helping newcomers adjust to life in the North. Young black men and women employed by the Urban League interviewed thousands of applicants for jobs, primarily in the city's industrial sector.

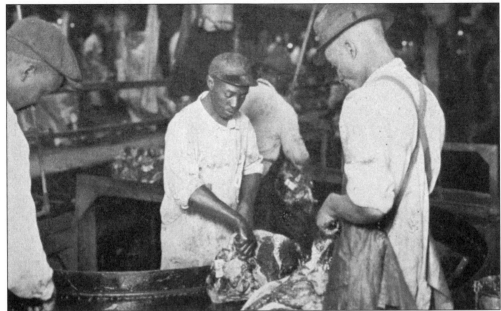

CHICAGO MEATPACKERS, C. 1925. The Urban League and other employment agencies sent thousands of job seekers to Chicago's meatpacking plants, making that industry the city's largest employer of African Americans. At the time, an extension of the city's elevated train line ran between the packing district and Douglas/Grand Boulevard, where most workers lived (the line no longer exists). African Americans remained about 25 percent of the industry's total work force until the plants and stockyards closed in the early 1970s.

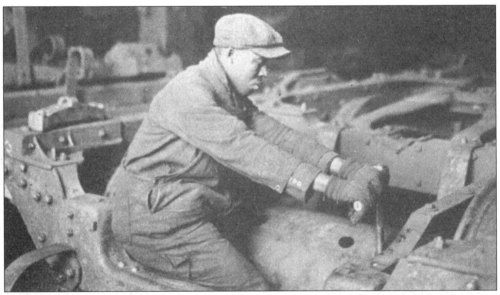

AFRICAN-AMERICAN STEEL WORKER, C. 1925. By 1920, more than four thousand African Americans worked in the steel industry, making it the second largest black employer after meatpacking. Compared to farm work in the South, both types of employment paid well, but the work was dirty and dangerous, and white-controlled unions in the steel industry barred blacks from joining until the 1940s, more than 20 years after meatpacking unions had allowed blacks to join.

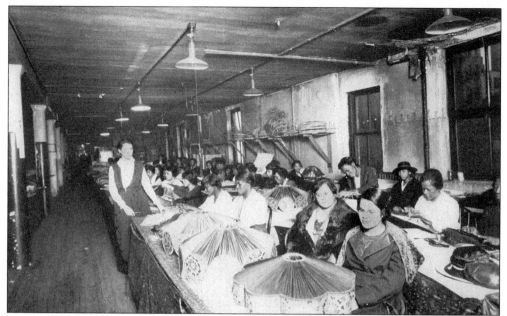

AFRICAN-AMERICAN WOMEN IN LAMP-SHADE FACTORY, C. 1925. Although most of Chicago's black working women were servants or hand laundresses, nearly 13 percent worked in factories. Like their male counterparts, they worked in poor conditions, yet earned considerably less money. Their efforts, however, helped secure a foothold for African-American families in the urban North.

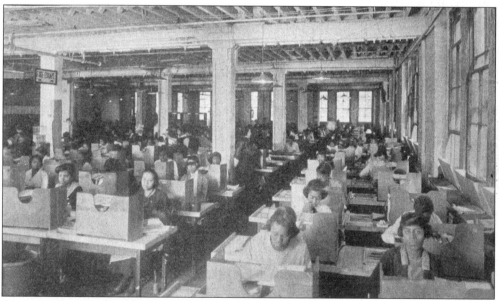

AFRICAN-AMERICAN CLERKS, C. 1925. During the 1920s, a small number of African Americans held white-collar jobs. They typically worked in offices of large companies, such as Sears, Roebuck & Company or International Harvester, or for black-owned businesses on the South Side.

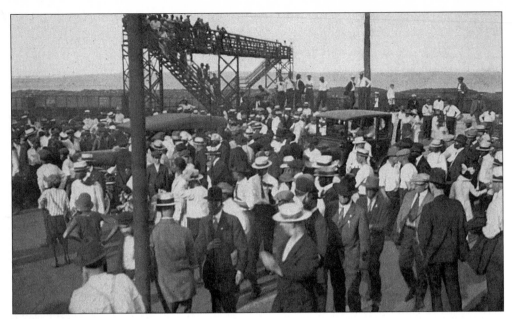

THE CHICAGO RACE RIOT: (ABOVE) *BEGINNING OF RACE RIOT* **AND (BELOW)** *WHITES STONING NEGRO TO DEATH,* **BY JUN FUJITA, 1919.** On July 27, 1919, Eugene Williams, a young African American, drowned at Twenty-ninth Street Beach. When Chicago police ignored charges that whites had stoned Williams to death after crossing an imaginary line separating the races, fighting broke out and quickly escalated into full-scale rioting that raged across the South Side for three days. Tragically, the riot claimed the lives of 23 African Americans and 15 whites, injured more than 500 people, and severely damaged race relations in Chicago, creating a bitter legacy that lasted decades.

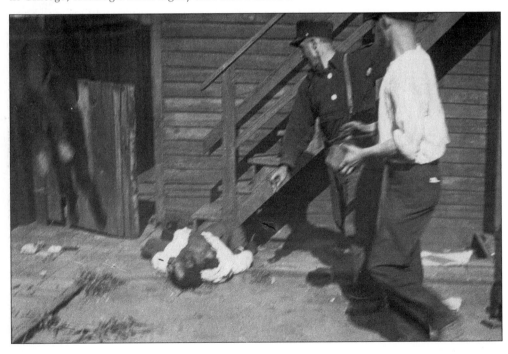

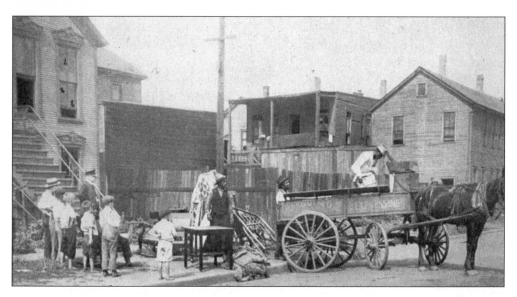

THE RIOT'S AFTERMATH: (ABOVE) *NEGROES UNDER PROTECTION OF POLICE LEAVING WRECKED HOUSE IN RIOT ZONE* AND (BELOW) *FIRE IN IMMIGRANT NEIGHBORHOOD "BACK OF THE YARDS"* BY JUN FUJITA. Rioting damaged millions of dollars worth of property in black and white neighborhoods across the South Side. Afterwards, Illinois Governor Frank O. Lowden appointed a biracial Commission on Race Relations, which cited a number of factors leading to the riot, including labor tensions and inadequate housing for blacks. Although the commission recommended that all citizens be granted equal rights and opportunity, Chicago's racial divisions grew deeper. During the 1920s, whites continued to move away from the inner city, and kept blacks out of their neighborhoods by acts of violence, or through restrictive covenants, that prevented the sale or rental of property to "people of color."

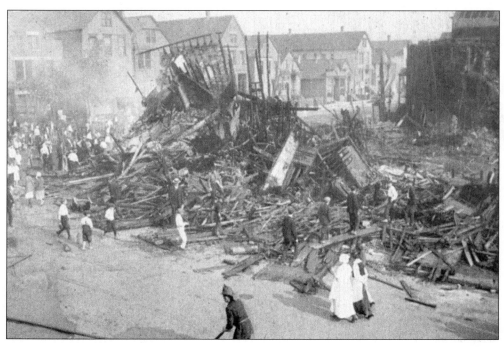

ILLINOIS

DAVID McGOWEN
Undertaker

L. P. JOHNSON
Real Estate Broker and General Contractor

FRANK L. GILLESPIE
President and Founder Liberty Life Insurance Co.

W. D. ALLIMONO
W. D. Allimono & Co., Certified Public Accountants

R. W. LEWIS
Industrial Engineer

OFFICERS

FRANK L. GILLESPIEPresident
Cor. Grand Blvd. and 35th St.
L. P. JOHNSON............................Vice-President
151 N. Peoria St.
DAVID McGOWENTreasurer
3515 Indiana Ave.
W. D. ALLIMONO............................Ex. Secretary
3456 Michigan Ave.
R. W. LEWISRec. Secretary
3456 Michigan Ave.

The above group constitutes the officers of the

Chicago Branch of National Negro Business League

This League was organized about three years ago; it has a membership of four hundred persons, composed of the most prominent colored business men and women in Chicago.

CHICAGO BRANCH OF NATIONAL NEGRO BUSINESS LEAGUE, 1923. As a racially segregated city within a city, Douglas/Grand Boulevard developed its own economy, becoming a national model of black achievement. Hundreds of black entrepreneurs lived and worked in the neighborhood, providing employment opportunities for scores of residents. About four hundred professional men and women belonged to Chicago's branch of the National Negro Business League located at 3456 Michigan Avenue.

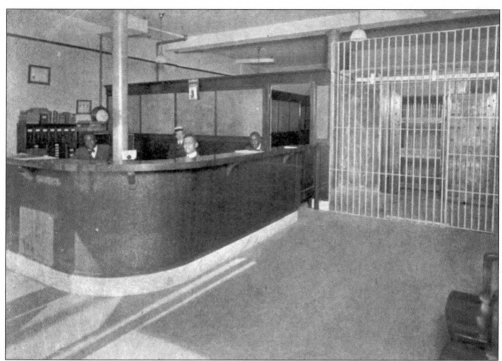

ADVERTISEMENT FOR REAL ESTATE AND INSURANCE, 1923. According to *Simms' Blue Book* of African-American businesses, more than 60 real estate agents worked in Douglas/Grand Boulevard. They catered to a growing number of middle and-upper-class African Americans, many of whom worked in the neighborhood. Anderson & Terrell, the first African-American real estate company, was located in the Jordan Building, a black-owned commercial structure at 3529–49 South State Street.

SOUTH SIDE PHARMACISTS, 1923. *Ford S. Black's Blue Book* of South Side businesses included a composite advertisement of several competing pharmacists in Douglas: Edward N. White, 4700 South State Street; Clarence A. McCoy, 3800 Rhodes Avenue; H.O. Turner, D.R. Turner, Raymond H. Thompson, and Charles S. Thompson, 456 East Thirty-seventh Street; and George M. Porter, 3510 South State Street.

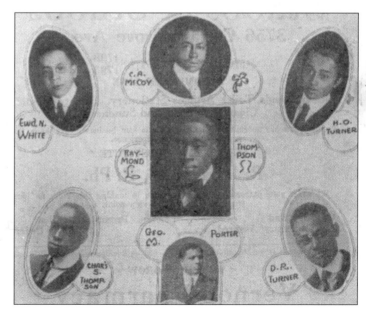

NELL D. CALLOWAY, AUDITOR, 1923. Black professional women played an important role in the economic life of Douglas/Grand Boulevard. Nell D. Calloway, one of the many women who placed advertisements in *Simm's Blue Book,* worked as an auditor for the state of Illinois. Originally from Chattanooga, Tennessee, Calloway attended Fisk University in Nashville and traveled throughout Europe before settling in Chicago at 3300 Rhodes Avenue.

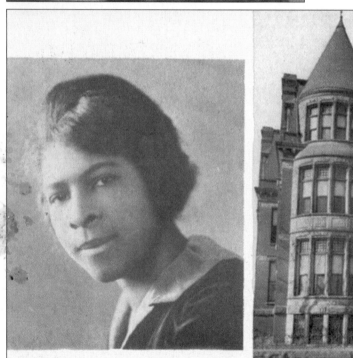

PAULINE JAMES LEE AND CHICAGO UNIVERSITY OF MUSIC, 1923. Originally from Missouri, Pauline J. Lee migrated to Chicago as a young girl in the early 1900s, attended Chicago Public Schools, and studied music at Northwestern University. After touring the eastern United States, Lee established Chicago University of Music at 3672 Michigan Avenue, where she taught hundreds of young students.

McGavock's, 1923. According to South Side directories, about 20 undertakers worked in Douglas/Grand Boulevard, including R.H. McGavock, who claimed to have the neighborhood's largest chapel at 3823–25 State Street. Like his competitors, McGavock offered out-of-town rail shipments to outlying cemeteries, or even further south to ancestral homes. In addition, McGavock had an elaborate "funeral palace car," or hearse, that could transport parties of 25 people to the cemetery.

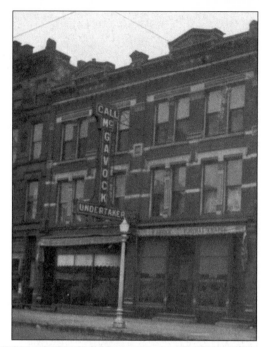

Robert R. Jackson, 1923. Born in Chicago, Robert R. Jackson owned and operated the Fraternal Press, the nation's largest black printing company. Previously, Jackson had worked for the Chicago Post Office as assistant superintendent the of Armour Station, and served in the Illinois National Guard during the Spanish-American War, achieving the rank of general. Jackson and his family lived at 3366 South Park Avenue (now King Drive).

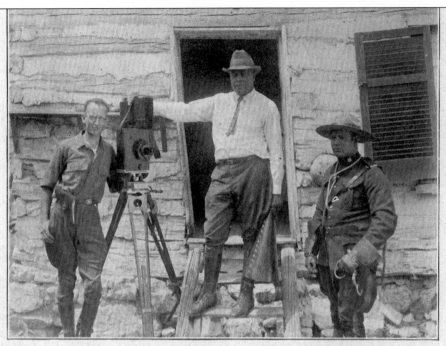

Micheaux Film Corporation

Producers and Distributors of
High Class Negro Feature Photoplays
Executive Offices — 3457 So. State St. — Chicago

Branch Offices	Officers
Congo Film Service	Oscar Micheaux, Pres.
Hampton Theatre	S. E. Micheaux, Sec. & Treas.
Roanoke, Va.	W. R. Cowan, Vice-Pres.
Adams & Sons	G. S. O'Neal, Jr.
Verdun Theatre	Traveling Representative
Beaumont, Texas	

PRODUCTIONS IN THE ORDER OF RELEASE

"THE HOMESTEADER"
7 Reels with Evelyn Preer and Chas. D. Lucas

"WITHIN OUR GATES"
7 reels with Evelyn Preer

"THE BRUTE"
7 Reels with Evelyn Preer and All Star Cast

"SYMBOL OF THE UNCONQUERED"
7 Reels with all Star Cast

"GUNSAULUS MYSTERY"
7 Reels with Evelyn Preer and All Star Cast

"THE DUNGEON"
7 Reels with Wm. E. Fountaine and All Star Cast

FORTHCOMING

"VIRGIN OF SEMINOLE"
7 Reels with Wm. E. Fountaine and Shingzie Howard

"THE HOUSE BEHIND THE CEDARS"
9 Reels by Chas. W. Chestnutt

"A FOOL'S ERRAND"
7 Reels with Wm. E. Fountaine and Shingzie Howard

"JASPER LANDRY'S WILL"
6 Reels with Wm. E. Fountaine and Shingzie Howard

"THE HYPOCRITE"
7 Reels with Evelyn Preer, Cleo Desmond and All Star Cast

"HOOKER'S BEND"
7 Reels with All Star Cast

MICHEAUX FILM COMPANY, 1923. Before Hollywood, Chicago was the movie capital of the world. In addition to white-owned Essanay and Selig studios on Chicago's North Side, Micheaux Film Corporation at 3457 South State Street produced hundreds of "high-class Negro feature photoplays" for eager audiences. Its owner, Oscar Micheaux, stands in the center of this photograph, between a white cameraman and an actor playing a Royal Canadian Mounted Policeman.

Keystone National Detective Agency

INCORPORATED

Secret Service

Private and Criminal Investigations

Finger Prints Dictagraphs Palm Camera Experts

Licensed and Bonded

We do not operate for rewards, neither do we handle divorce cases

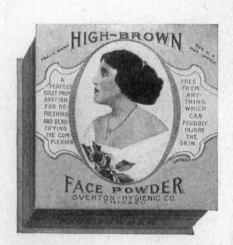

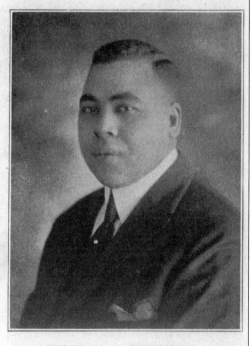

HIGH-BROWN FACE POWDER

Over 4,000,000 Boxes Sold in 1921.

Over four million boxes of High-Brown Face Powder sold last year is evidence that quality is still appreciated—and will be always.

Qualities, 25c, 50c, 75c.

Four shades, Natural, White, Flesh-pink and Brunette.

See that our name is on every package.

Overton-Hygienic Mfg. Co.

CHICAGO

SHERIDAN A. BRUSEAUX

Born April 26, 1890, Little Rock, Ark. Finished public schools Little Rock, 1906. Finished University of Minnesota, 1913. Engaged in Secret Service in U. S. and Europe in 1914 to 1919.

Founded Keystone National Detective Agency, October 3rd, 1919.

The Keystone National Detective Agency is the pioneer and only Colored Licensed and Bonded Detective Agency in the World.

KEYSTONE NATIONAL DETECTIVE AGENCY, 1923. A self-contained community, Douglas/Grand Boulevard had every kind of business imaginable, including detective agencies. Sheridan A. Bruseaux, founder of Keystone National Detective Agency, was originally from Little Rock, Arkansas; he graduated from the University of Minnesota, and engaged in secret service overseas during World War I. (note: the Overton-Hygienic Manufacturing Company is discussed in more detail on page 70).

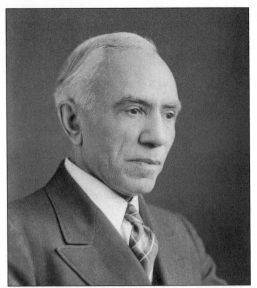

FRED J. BRAXTON, D.D.S., C. 1935. (COURTESY MURIEL B. WILSON) Medical professionals formed an elite group in Douglas/Grand Boulevard. Fred J. Braxton, a Chicago native and graduate from Northwestern Dental School, maintained a practice in Douglas/Grand Boulevard for more than 40 years, receiving numerous awards for his dedicated service to the community.

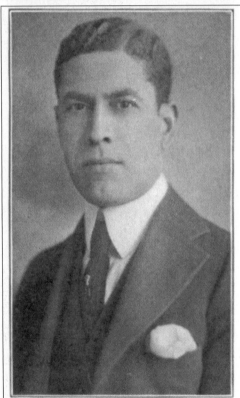
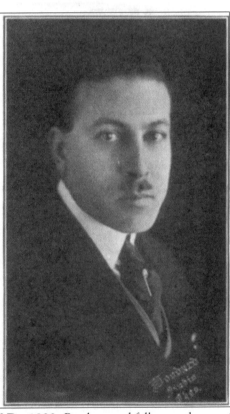

PARK TANCIL, D.D.S., AND LEON A. TANCIL, M.D., 1923. Brothers and fellow graduates of Howard University, Park and Leon Tancil practiced together on the corner of Thirty-first Street and Indiana Avenue. During World War I, Park Tancil served with Chicago's famous Eighth Illinois Regiment and was decorated by the French government for distinguished service. They claimed to have "the most modern and completely equipped" medical office on the South Side.

FANNIE EMANUEL, M.D., 1923. A graduate of Chicago Hospital College of Medicine, Fannie Emanuel practiced in Douglas/Grand Boulevard and belonged to many of its civic organizations, including Ida B. Wells Woman's Club, Woman's Aid of Old Folks, and the Y.W.C.A. Dr. Emanuel lived with her husband, William, their three sons, and one daughter at 6352 Rhodes Avenue.

DR. ULYSSES GRANT DAILEY. 1923. Born in Louisiana and educated at public schools in Texas, Ulysses G. Dailey graduated from Northwestern University Medical School in 1906. After working as an ambulance surgeon for the Chicago Health Department, Dailey practiced surgery at Provident Hospital and taught at Chicago Medical College. Dailey and his family lived in a handsome greystone at 4356 Calumet Avenue.

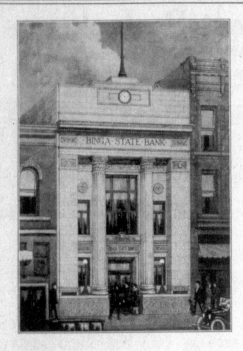

For Over 18 Years

the name of this institution has stood for all that is substantial and dependable in financial affairs in the middle south side.

✌

CAPITAL and SURPLUS
$245,000

OFFICERS

JESSE BINGA, President
JOHN R. MARSHALL, Vice President
C. N. LANGSTON, Cashier

DIRECTORS

JESSE BINGA	JOHN R. MARSHALL
C. H. CLARK	A. H. ROBERTS
U. G. DAILEY	W. A. ROBINSON
OSCAR DE PRIEST	THOS. R. WEBB
C. N. LANGSTON	A. W. WILLIAMS
R. A. WILLIAMS	

BINGA STATE BANK

South State at Thirty-Fifth Street

Affiliated Member Chicago Clearing House Association

Advertisement for Binga State Bank, 1927. Owned by an African American, Jesse Binga, the Binga Bank opened in 1908. At its height during the mid-1920s, the bank had assets of more than $1 million, making it one of the largest African-American financial institutions in the country. Like countless other banks across the country, the Binga Bank collapsed during the Great Depression.

Jesse Binga, 1927. In addition to the bank, Jesse Binga (1865–1950) owned a considerable amount of real estate on the South Side. During the Great Depression, Binga's fortunes collapsed; convicted for embezzling bank funds, he spent several years in prison before being pardoned in 1938. Binga spent his remaining years working as a janitor on the South Side.

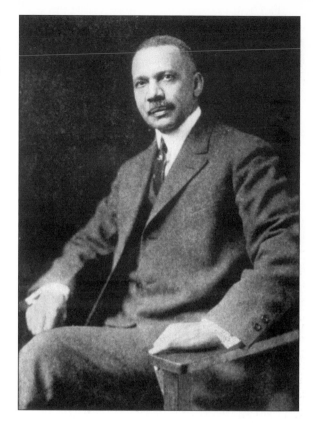

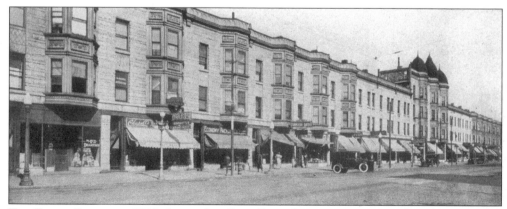

The Binga Block, c. 1925. Located on State Street between Forty-seventh and Forty-eighth Streets, the "Binga Block" was home to many black-owned businesses, including a milliner, pharmacy, barber shop, beauty parlor, photographer, fish market, tailor, and florist. The convenience of neighborhood shopping, plus the fact that blacks were not welcomed downtown, helped the South Side businesses flourish.

ANTHONY OVERTON, 1925. One of Chicago's most successful African Americans, Anthony Overton (1865–1946) built an economic empire in Douglas/Grand Boulevard. His holdings included the Overton Hygienic Company, a cosmetics firm, *The Half Century Magazine*, the *Chicago Bee* newspaper, Douglass Bank (named after the famous black abolitionist Frederick Douglass), and Victory Life Insurance Company.

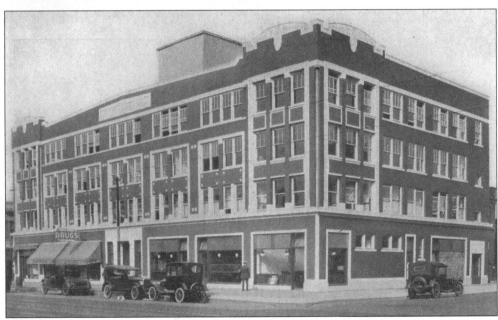

OVERTON HYGIENIC BUILDING, 3621 SOUTH STATE STREET, 1925. This spacious, four-story building housed Overton's bank, insurance company, cosmetics firm, and publishing company; several smaller enterprises occupied additional offices. The bank, located on the ground floor, featured marble floors and counters, and walnut woodwork and furniture. Still standing, the building is currently undergoing renovation.

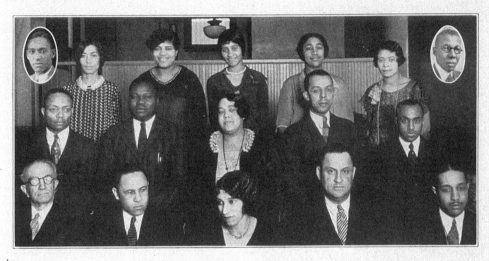
STAFF OF THE CHICAGO BEE, 1925. Established in 1925, *The Chicago Bee* successfully competed with its older and more sensationalistic rival, *The Chicago Defender*, for African-American readership. Originally located in the Overton Hygienic Building, the *Bee* later moved to its own building at 3647–55 South State Street after Overton's bank failed during the Great Depression. *The Chicago Bee* remained in print until the early 1940s.

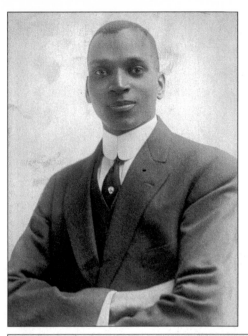

CLAUDE A. BARNETT, C. 1905. Born in Sanford, Florida, Claude A. Barnett (1889–1967) moved to Chicago as a young child. After graduating from Tuskegee Institute, Barnett established the Associated Negro Press in 1919 as a news-gathering agency that sent news releases to hundreds of African-American newspapers across the country. Voting rights, desegregation of the armed forces, and equal access for African-American journalists were among the many issues advanced by the ANP.

Clean, Constructive, Reliable News

Watch your Newspaper for the Credit Line: "By The Associated Negro Press"

First In Service

THE ASSOCIATED NEGRO PRESS
(Incorporated)

Serves One Hundred and Twelve, (112) newspapers with the latest news affecting the Civic, Business, Religious, Educational, Industrial, Political and Social activities of the Race.

Buy the paper which carries A. P. credit lines.

We invite correspondence and will be glad to receive at all times news of National Importance affecting the Race.

Phones: Douglas 3741-3726
3423 Indiana Ave., Chicago, Illinois.

ANP MASTHEAD, NOVEMBER 13, 1929. In addition to its Chicago headquarters at 3423 South Indiana Avenue, the Associated Negro Press had offices in New York, Boston, Atlanta, New Orleans, Kansas City, and several other cities across the United States. ANP's masthead featured an eagle holding a scroll inscribed "Progress, Loyalty, Truth." The company remained in business until Barnett retired in 1964.

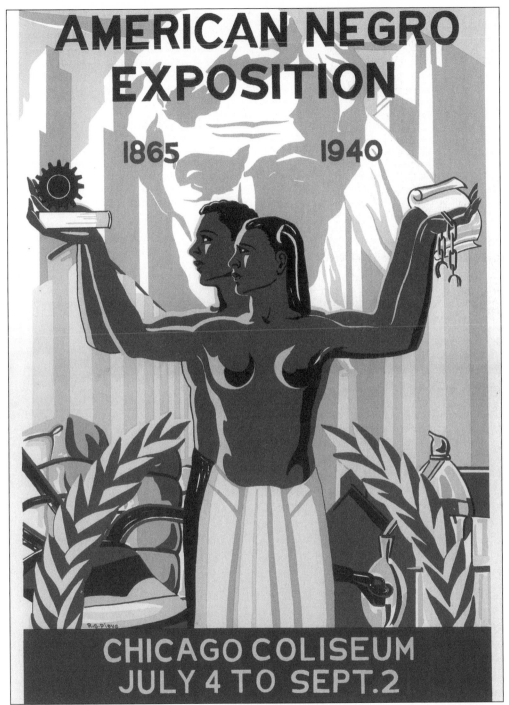

AMERICAN NEGRO EXPOSITION POSTER, 1940. Among his many activities, Claude Barnett helped organized the American Negro Exposition to "develop the contributions of the Negro to American life and his progress in his seventy-five years of freedom." Held at the Chicago Coliseum from July 4 to September 2, 1940, the exposition included exhibitions on education, business, industry, art, music, religion, and sports.

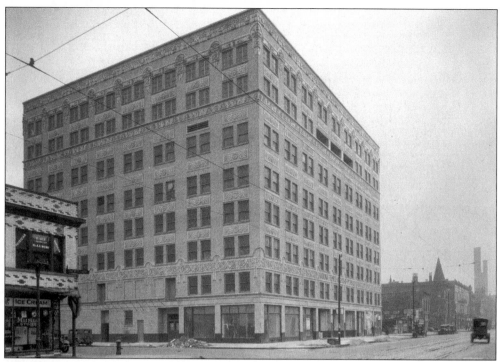

THE KNIGHTS OF PYTHIAS TEMPLE, 1928 In 1924, the Knights of Pythias, a fraternal organization dedicated to charitable works, commissioned Walter T. Bailey, Chicago's first black architect, to design its international headquarters at Thirty-seventh Place. Completed in 1928, the eight-story structure towered over other buildings in the area; it was demolished in 1980. Bailey later designed the First Church of the Deliverance at 4315 South Wabash Avenue.

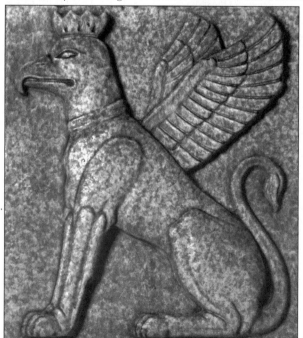

GRIFFIN FIGURE FROM THE KNIGHTS OF PYTHIAS TEMPLE, 1928. Designed by architect Walter T. Bailey, several hundred terra-cotta griffin figures embellished an upper frieze of the Pythias Temple. According to Greek mythology, griffins guard a great store of gold in Scythia, a country far north of Greece.

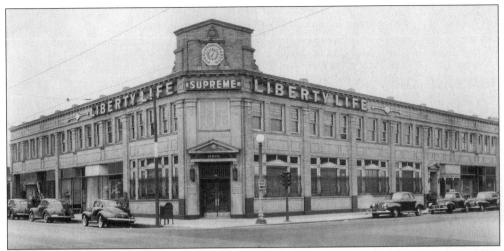

LIBERTY LIFE/SUPREME LIFE INSURANCE BUILDING, C. 1940. Erected in 1921, this building originally housed the Liberty Life Insurance Company, the first black-owned life insurance company in the North, and its successor, the Supreme Life and Casualty Company. Extensively remodeled in 1957, the building still stands at Thirty-fifth Street and King Drive and remains an important symbol of African-American enterprise despite its deteriorating condition.

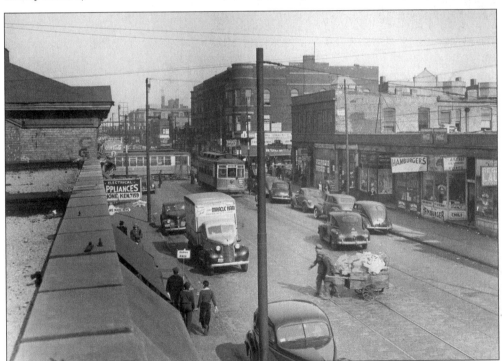

FORTY-SEVENTH STREET, BY RUSSELL LEE, 1941. (COURTESY LIBRARY OF CONGRESS) During the mid-1920s, a new commercial strip sprang up around Forty-seventh Street and competed with shops on Thirty-fifth and State Streets. Unlike its older rival, Forty-seventh Street was largely controlled by white merchants, who had more financial resources to survive the Great Depression. During World War II, shops and nightclubs along Forty-seventh Street flourished, but declined during the 1950s when middle-class residents began moving away from the area.

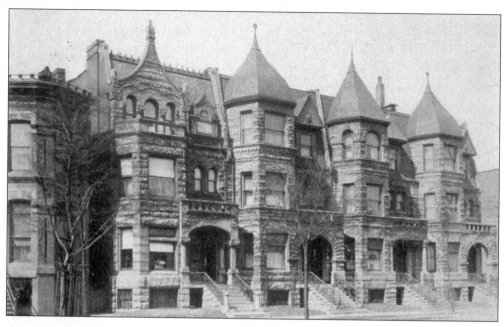

SOUTH PARK AVENUE (NOW KING DRIVE) (ABOVE) AND FORTY-EIGHTH STREET AND CHAMPLAIN AVENUE (BELOW), C. 1925. Living within a segregated neighborhood, African Americans established a vibrant, yet stratified community of their own in Douglas/Grand Boulevard. Lower-income blacks lived west of State Street in worker cottages once inhabited by Irish and European immigrants, while those with higher incomes lived further east in gray- and brownstone houses built around the turn of the century for middle and upper-income whites. Like their predecessors, African Americans steadily moved south towards Washington Park, but unlike whites, blacks could not move beyond Fifty-first Street until the late 1940s, after the U.S. Supreme Court struck down restrictive covenants that barred whites from selling their homes to "people of color."

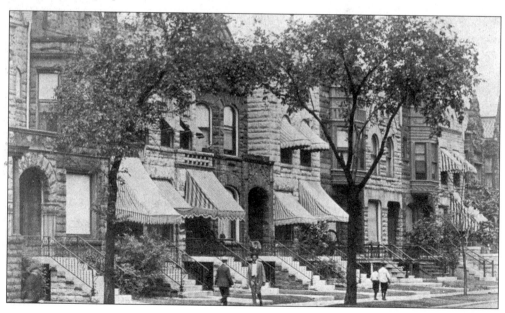

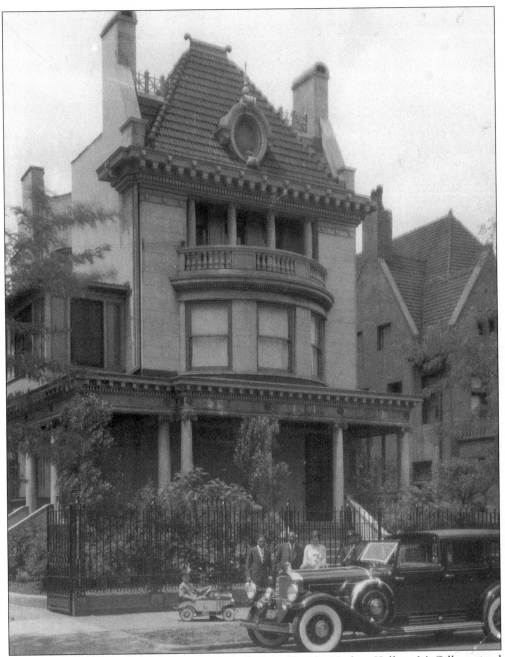

NATHAN K. MCGILL RESIDENCE, C. 1930. Born in Florida, Nathan Kellogg McGill received a law degree from Boston University in 1912 and moved to Chicago during the 1920s. McGill worked as general consul and secretary for Robert S. Abbott Publishing Company, and lived with his family at 4806 South Parkway (now King Drive). A Republican, McGill served as Illinois's first African-American assistant state's attorney (1925–26) and ran for judicial office several times.

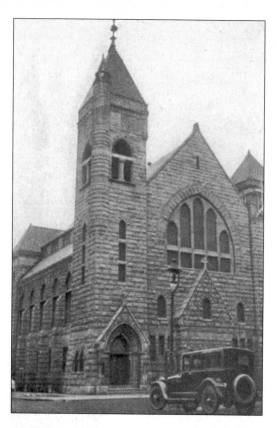

QUINN CHAPEL, AFRICAN METHODIST EPISCOPAL CHURCH. Originally established downtown in 1847, Quinn Chapel is Chicago's oldest African-American church. After the 1871 Chicago Fire, it moved to Twenty-fourth Street and Wabash Avenue. Many elite "old settlers" who lived in Chicago before the Civil War belonged to Quinn Chapel, and its long line of distinguished pastors included Rev. Archibald James Carey Sr., an outstanding orator elected bishop in 1920.

METROPOLITAN COMMUNITY CHURCH OF CHICAGO. Established in 1920, the Metropolitan Community Church at 4106 South Parkway (King Drive) had more than nine thousand members. Its various activities included a choir, glee club, and social service club that furnished large quantities of clothing and shoes to needy families on the South Side.

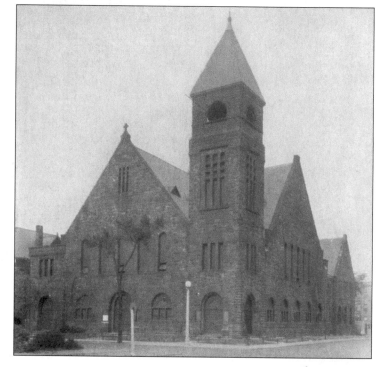

OLIVET BAPTIST CHURCH, THIRTY-FIRST STREET AND KING DRIVE, C. 1930. Founded in 1850, Olivet Baptist Church has occupied this structure since 1917. At the time, pastor Lacey Kirk Williams and assistant pastor, J.H. Branham, encouraged their congregation, which included many recent migrants, to support local businesses as a means to improve economic conditions for African Americans living in Chicago. (First Baptist Church originally constructed the building in 1875.)

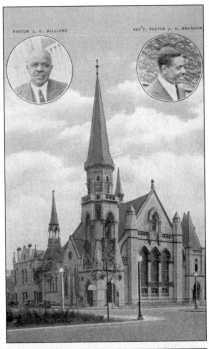

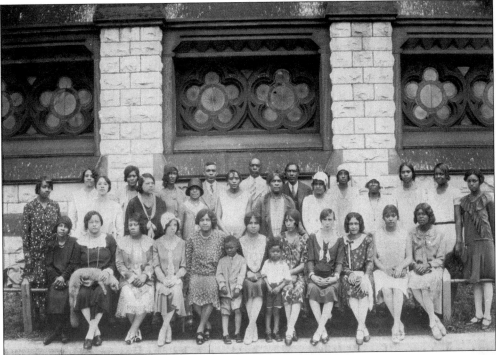

MEMBERS OF OLIVET BAPTIST CHURCH, C. 1925. During the 1920s, more than ten thousand African Americans belonged to Olivet Baptist, making it the largest black Baptist congregation in America. Many members were newcomers, and, in addition to regular Sunday services, the church provided them with a wide variety of social activities and support, from sewing bees and Sunday school to finding jobs and living quarters.

TAKE MY HAND, PRECIOUS LORD

SPECIAL ARRANGEMENT
FOR MIXED VOICES
WITH DUETT AND TRIO

by

THOMAS A. DORSEY

PRICE 50 CENTS

THOMAS A. DORSEY
MUSIC PUBLISHER
4154 S. Ellis Ave., Chicago, Illinois. 60653

"TAKE MY HAND, PRECIOUS LORD," BY THOMAS A. DORSEY. (COURTESY TIMOTHY SAMUELSON.) Considered a classic of gospel music, "Take My Hand, Precious Lord" was written by Thomas A. Dorsey (1899–1993) of Chicago. Revered as "The Father of Gospel Music," Dorsey moved from Georgia to Chicago during the Great Migration. He began his career as a blues musician, but after turning to religion, melded blues with jazz to create new style of music known as "gospel," which became enormously popular in African-American churches across the country.

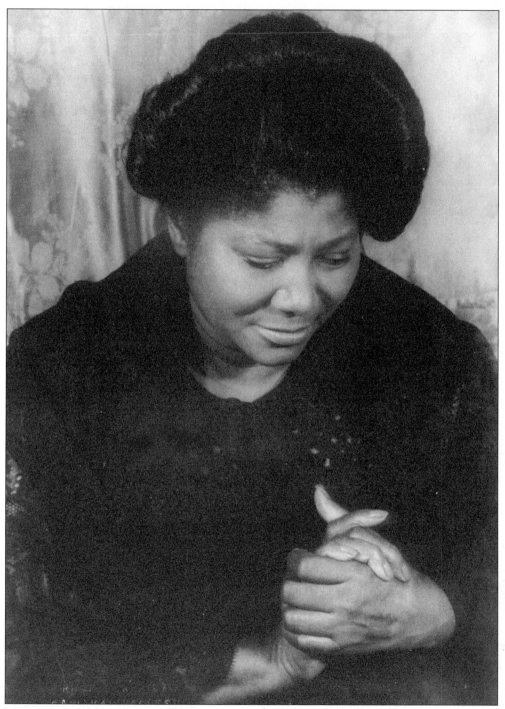

MAHALIA JACKSON, C. 1965. Born in New Orleans, Mahalia Jackson (1911–72) moved to Chicago at age 16, and worked as a laundress, hotel maid, and beautician before becoming a gospel star with her first recording, "Move On Up a Little Higher," issued in 1934. A member of the Greater Salem Baptist Church Choir, Jackson often collaborated with Thomas A. Dorsey at Pilgrim Baptist Church and played an active role in the Civil Rights Movement.

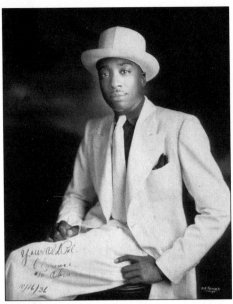

REVEREND CLARENCE H. COBBS, 1936.
Originally from Tennessee, Clarence H.
"Preacher" Cobbs founded the First Church of
Deliverance in Chicago in 1929. Compared to
older, more traditional churches in
Douglas/Grand Boulevard, First Church had a
more rural membership and its services were
less formal. In 1934, First Church became the
first American church to broadcast its services
live on radio, popularizing the sounds of gospel
music to a larger audience.

FIRST CHURCH OF DELIVERANCE. A gospel songbook published by First Church of Deliverance features an image of its building at 4315 South Wabash Avenue. Still standing, the church was originally built as a hat factory, but redesigned as an Art Deco structure in 1939 by Walter T. Bailey, an African-American architect who also designed the Knights of Phythias Temple at Thirty-seventh Place (see p. 74).

RALPH H. GOODPASTEUR, C. 1960. For over 40 years, Ralph Goodpasteur served as minister of music at the First Church of Deliverance. Under his direction, the choir toured America and Europe and recorded albums with such noted jazz artists as Nat King Cole and Earl "Fatha" Hines. Goodpasteur also wrote and published hundreds of gospel songs.

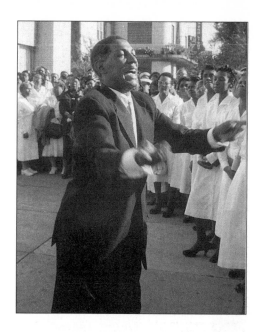

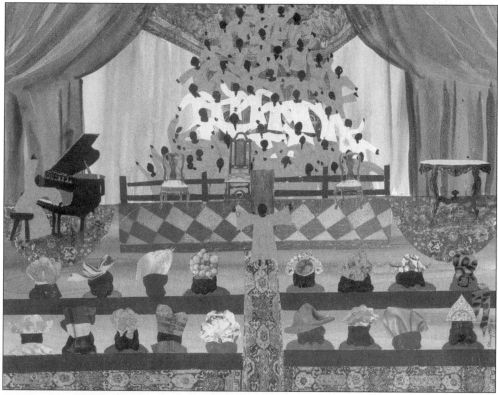

"LADIES DAY IV," C. 1989. A paper collage by Chicago artist Allen Stringfellow captures the spiritual exuberance of gospel music. During the 1960s and 1970s, gospel music reached new heights of popularity with big-name artists such as Mahalia Jackson, who adhered to a traditional style, and Aretha Franklin, who blended gospel with the contemporary sounds of rock-n'-roll.

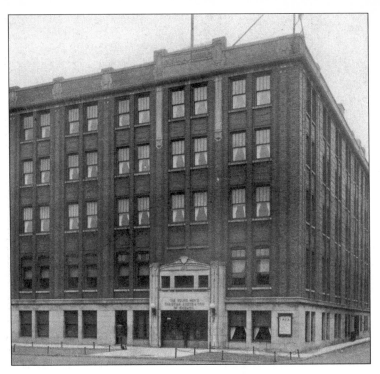

WABASH AVENUE YMCA, 1923. The "Wabash Y" at 3753 Wabash Avenue played an important role in the history and social fabric of Douglas/Grand Boulevard. In addition to assisting newcomers during the Great Migration, the Y offered temporary lodging, home-cooked meals, instructional classes, gymnasium, game rooms, and many social programs. The building is currently being renovated as a community center with SROs, single-room-only housing for men.

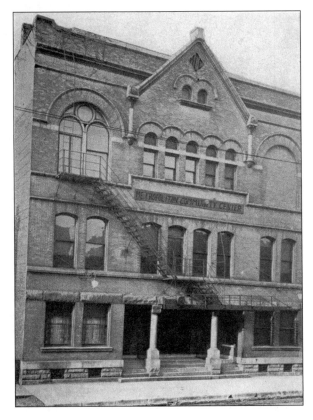

METROPOLITAN COMMUNITY CENTER, 1923. One of the larger charitable organizations in Douglas/Grand Boulevard, the Metropolitan Community Center at 3118 Giles Avenue assisted African-Americans with issues of employment, child welfare, workers' rights, and race relations. Supported by the Metropolitan Church, the center also sponsored girls' and boys' clubs, Sunday evening social clubs, music programs, and community singing.

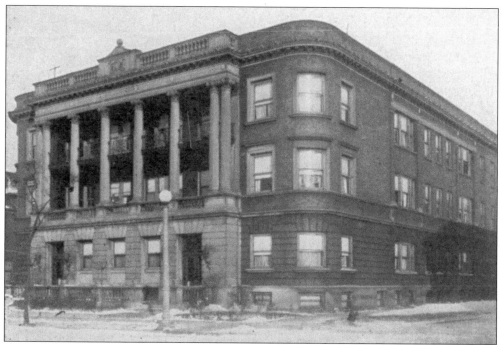

YWCA, 1923. Located at 3541 South Indiana Avenue, the YWCA served as an important social center in Douglas/Grand Boulevard. During its peak in the 1920s, the Y enrolled nearly five hundred women in various classes, including bible study, cooking, millinery, glee club, dramatics, and stenography. In addition, the Y housed a gymnasium, library, and temporary lodging for 30 women.

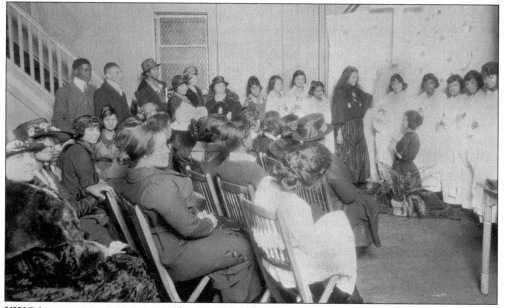

YWCA PROGRAM, 1921. As a Christian organization, the Y offered religious programs such as "Memories of Calvary," an Easter pageant with an all-female cast. The Y also prepared many young women to assume leadership roles in the African-American community later in life.

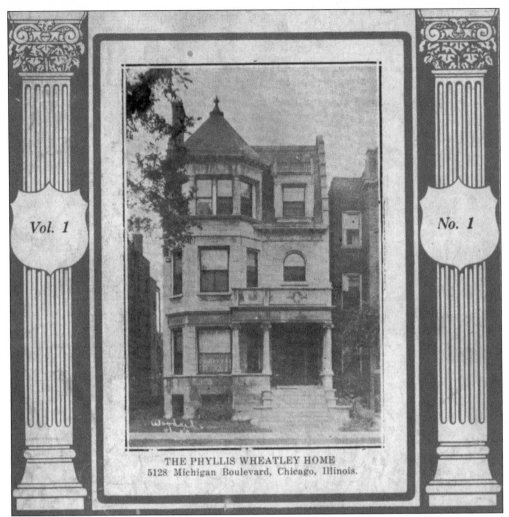

THE PHYLLIS WHEATLEY HOME
5128 Michigan Boulevard, Chicago, Illinois.

PHYLLIS WHEATLEY HOME, C. 1925. Named after the famed African-American poet, the Phyllis Wheatley Home cared for "honest working girls friendless in Chicago." It assisted young women, predominately from the rural South, with housing, health care, employment, recreation, and religious guidance. Originally located on Forest Avenue, the home moved to larger quarters on Rhodes Avenue before settling at 5128 Michigan Boulevard in 1926.

HOME FOR AGED COLORED PEOPLE, C. 1925. Located at 4430 Vincennes Avenue, the Home for Aged Colored People was founded in 1893 as a shelter for elderly and "friendless" African-Americans. Entirely supported by charitable contributions and benefits, the home sponsored various programs, such as an Amateur Minstrels' Entertainment and Dance given every Easter Monday at the Eighth Regiment Armory and an annual tag-day of the Chicago Federation of Aged and Adult Charities.

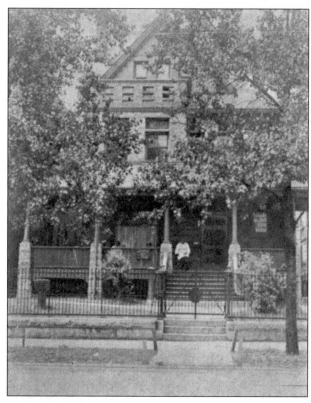

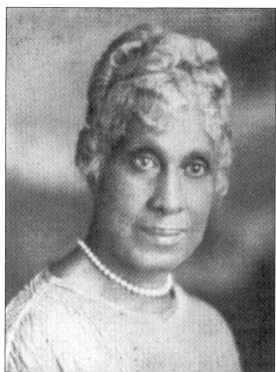

ELIZABETH LINDSAY DAVIS, 1928. A tireless volunteer, Elizabeth Lindsay Davis founded the Phyllis Wheatley Home in 1905 and served as its chairman. She enlisted the help of many prominent residents of Douglas/Grand Boulevard, including millionaire banker Jesse Binga, who served as treasurer of appeals fund. Under her guidance, the home assisted thousands of young African-American women.

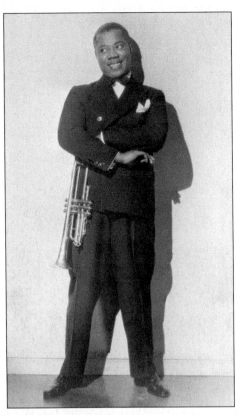

LOUIS ARMSTRONG, C. 1940. Legendary jazz musician, Louis Armstrong (1900–71) began his career in his hometown of New Orleans before moving to Chicago in 1922 to play with Joseph "King" Oliver's Creole Jazz Band on the city's South Side. Later, Armstrong formed his own bands of New Orleans musicians, known as the Hot Five and Hot Seven; between 1925 and 1928, they cut several recordings in Chicago which had an enormous impact on American jazz.

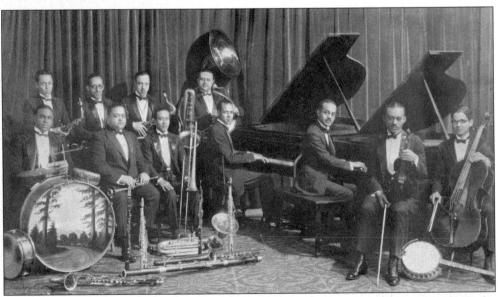

CLARENCE STEWART BAND, 1927. Like many early jazz groups, little is known about the Clarence Stewart Band, but they helped make Chicago the jazz capital of America during the 1920s. Musicians from all over the country, including Jimmy McPartland, Benny Goodman, and Art Hodes from Chicago's West Side, flocked to nightclubs on the South Side, then introduced the hot sound to white audiences.

EARL "FATHA" HINES, 1945. Originally from Pittsburgh, jazz pianist Earl "Fatha" Hines (1903–83) moved to Chicago in 1923 and performed with Louis Armstrong before establishing his own band. During the 1930s, Hines regularly performed at the Savoy Ballroom and Grand Terrace, two of Chicago's most popular dance clubs.

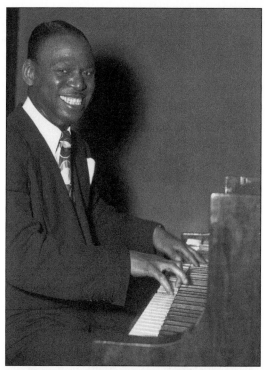

THE PALM TAVERN, C. 1945. Located at 446 East Forty-seventh Street, the Palm Tavern opened in 1933, and became one of Douglas/Grand Boulevard's most important nightclubs. Entertainers including Duke Ellington, Billie Holiday, Count Basie, Miles Davis, and Muddy Waters made appearances. Today, the Palm Tavern, operated by Gerri Oliver, is threatened by the city's re-development plans, which may close or relocate one of the last remaining nightspots in Bronzeville.

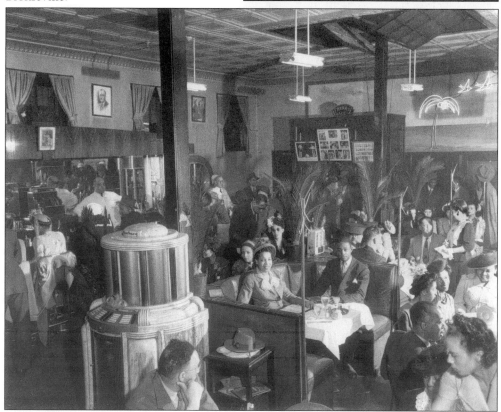

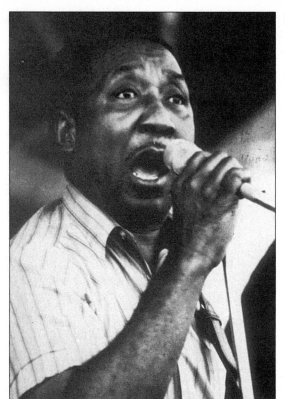

MUDDY WATERS, 1972. Many great blues artists have lived and worked in Douglas/Grand Boulevard, including the legendary Muddy Waters (1915–83). Born McKinley Morganfield in Mississippi, Waters moved to Chicago in 1943, played in local clubs, and made several recordings for Chess Records. Using an electric guitar, Waters developed a rugged style of blues that greatly influenced many rock-n'-roll artists. Known as the "King of Chicago Blues," Waters earned several Grammy awards for his music.

WILLIE DIXON AT ORLY AIRPORT, PARIS, 1964. Like Muddy Waters, Willie Dixon (1915–92) came from Mississippi. He moved to Chicago during the 1920s, and worked as a professional boxer before turning to music. During the 1950s, Dixon recorded for Chess Records, produced most of their releases, and composed many songs, including the well-known "Hoochie Coochie Man" for Muddy Waters and "Wang Dang Doodle" for Koko Taylor.

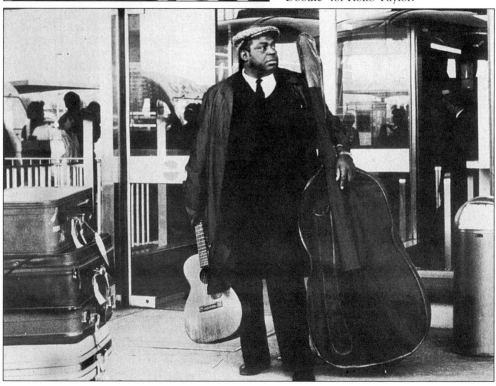

GWENDOLYN BROOKS, C. 1955.
Nationally renowned poet
Gwendolyn Brooks (1917–2000)
was born in Topeka, Kansas, but
grew up in Douglas/Grand
Boulevard. Brooks's early works,
largely based on her own life,
include *A Street in Bronzeville*,
Maud Martha, and *Annie Allen*, a
poetic ballad about African-
Americans in Chicago for which
she received a Pulitzer Prize in
1950. As poet laureate of
Illinois, Brooks encouraged
many young writers to pursue
their craft.

RICHARD WRIGHT, C. 1950.
(COURTESY GEORGE W. NOE.) Born in
Mississippi, Richard Wright (1908–60)
moved to Douglas/Grand Boulevard in
1927. His dramatic first novel, *Native
Son* (1940) recounts the story of Bigger
Thomas, an impoverished young man
who lives on Chicago's South Side.
Wright based his work on a true
incident of a young black man executed
for murdering a white girl, and it
remains a searing indictment of race
relations in America.

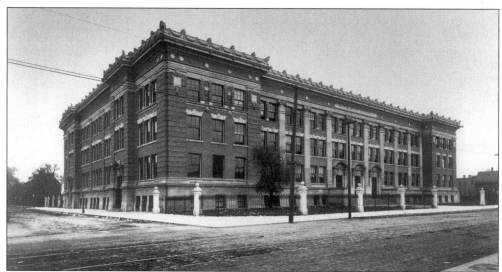

WENDELL PHILLIPS HIGH SCHOOL. Named after the famed nineteenth-century abolitionist from Boston, Wendell Phillips High School opened at Thirty-ninth Street and Prairie Avenue in 1904, and educated an increasing number of African Americans after World War I. It remained the neighborhood's only high school until 1935, when Du Sable High School opened, and became known for its dedicated teachers, competitive sport teams, and spirited marching bands.

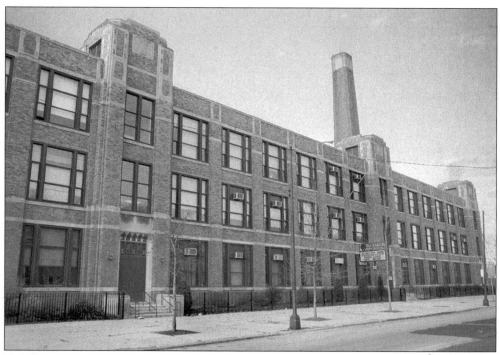

DU SABLE HIGH SCHOOL. Located at 4936 South Wabash Avenue, Du Sable High School is named after Chicago's first permanent settler, Jean Baptiste Du Sable, an African-American fur trader. The school opened in 1935 as an extension of Wendell Phillips to handle an increasing number of African-American students on the South Side. The administration and staff of both schools remained predominantly white until the 1960s.

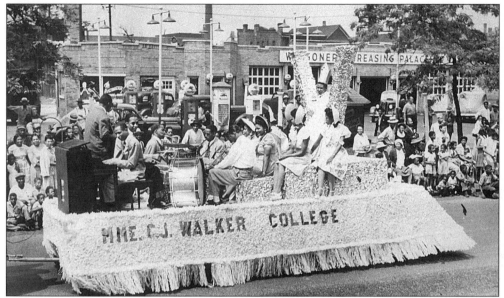

BUD BILLIKEN DAY PARADE, 1948 (COURTESY GEORGE W. NOE). Originally organized in 1929 by the *Chicago Defender*, the Bud Billiken Day Parade takes its name from a Chinese mythical god who represents "things as they should be." Over the years, local businesses, such as Madame C.J. Walker Beauty College, have sponsored floats that make their way down King Drive (formerly Grand Boulevard) to Washington Park. Held each August, the parade remains a popular event.

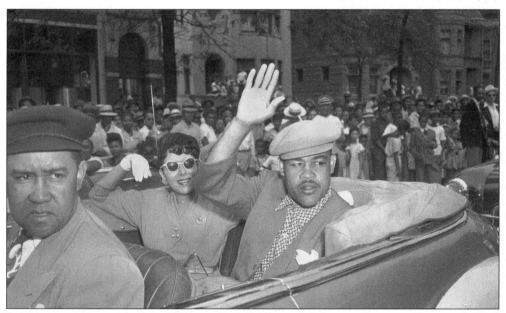

JOE LOUIS AT THE 1941 BUD BILLIKEN DAY PARADE. Celebrities often participate in the Bud Billiken Day Parade, and in 1941, boxer Joe Louis with his wife, the former Marva Trotter, a well-known big band singer, thrilled crowds along Grand Boulevard. Between 1937 and 1949, Louis reigned as heavyweight champion of the world, and remained one of America's most popular heroes for many decades.

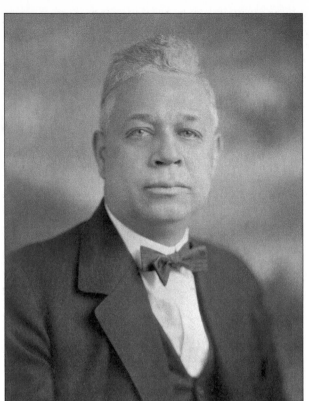

OSCAR S. DE PRIEST, C. 1930.
Born in Alabama, Oscar Stanton
De Priest (1871–1951) moved to
Chicago in 1889, and became
deeply involved in Chicago
politics. A Republican, De Priest
served as Cook County
Commissioner and the city's first
black alderman from the Second
Ward before being elected in
1928 as the nation's first black
congressman since
Reconstruction. De Priest served
three terms in Congress until
Arthur W. Mitchell defeated him
in 1934.

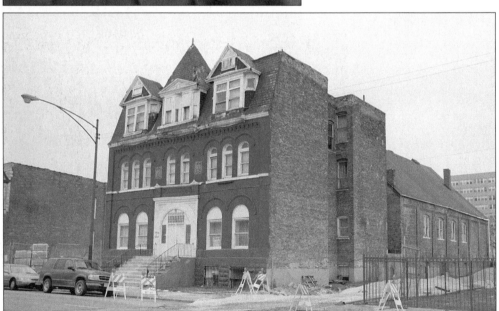

UNITY HALL, 3140 SOUTH INDIANA AVENUE. Originally erected in 1887 as the Lakeside
Club, a Jewish social organization, Unity Hall served as official headquarters of the People's
Movement Club, a political organization led by Oscar De Priest. It later became Congressman
William L. Dawson's political headquarters. Still standing, the structure currently houses
Jerusalem Church.

OSCAR DE PRIEST CHARITY CLUB, 1925. Organized in honor of the congressman in 1929, the Oscar De Priest Charity Club had about 75 members who worked on various projects, including a home for convalescents. Their motto, "Lifting As We Climb," reflected a general sense of self-reliance and mutual support in the black community.

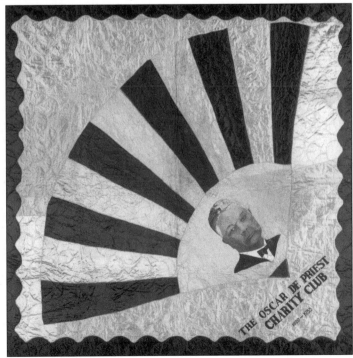

OSCAR DE PRIEST CHARITY CLUB QUILT, c. 1930. Made by club members to help raise funds, this quilt features a hand-painted oil portrait of Oscar De Priest against a gold and blue satin background. Although plagued by scandal early in his career, Congressman De Priest became a national figure, speaking out against discrimination from Capitol Hill and throughout the South.

IRENE MCCOY GAINES, C. 1925. Well-known community activist Irene McCoy Gaines (1892–1964) fought for better housing in Douglas/Grand Boulevard. During the 1930s, she served on President Herbert Hoover's National Committee on Negro Housing, compiling an influential report on living conditions in the neighborhood as compared to white neighborhoods. Her efforts led to the construction of the Ida B. Wells Homes, Chicago's first public housing for low-income African Americans.

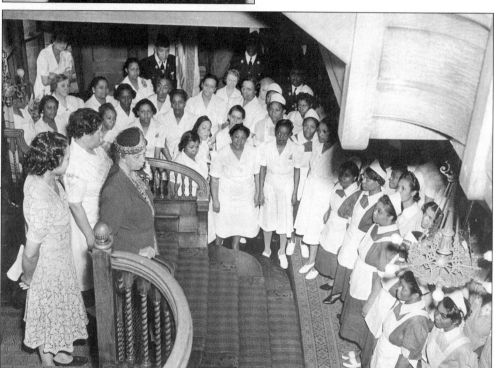

IRENE MCCOY GAINES WITH ELEANOR ROOSEVELT, 1935. Although a Republican, Gaines worked with Franklin D. Roosevelt's administration to improve conditions for African-Americans in Chicago. Here, Gaines is seen with First Lady Eleanor Roosevelt addressing a group of women on Chicago's South Side. In addition to housing, Gaines urged lawmakers to improve schools and medical facilities for blacks.

Vote For
☒ IRENE McCOY GAINES

REPUBLICAN CANDIDATE For
Representative In The
GENERAL ASSEMBLY
FIRST SENATORIAL DISTRICT

A Woman Trained and Experienced Who Has Rendered
Outstanding Service to Her People.

Primary Election
Tuesday, April 9, 1940

Polls Open From 6 in the Morning Until 5 in the Afternoon

GAINES CAMPAIGN POSTER. In 1940, Irene McCoy Gaines ran as the Republican candidate for the Illinois House of Representatives. By this time, a majority of African Americans had switched their political allegiance to Franklin D. Roosevelt's Democratic Party and Gaines lost the election. Nonetheless, Gaines remained politically active for the rest of her life.

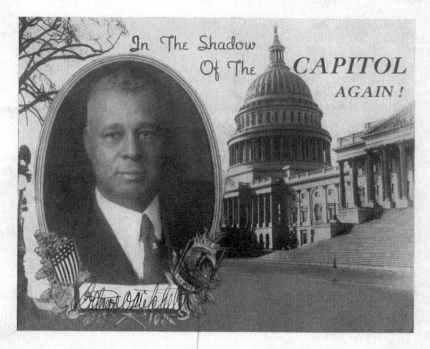

Arthur W. Mitchell

A Leader in the Nation's Capitol

In The Shadow Of The CAPITOL AGAIN!

Congressman Arthur W. Mitchell
is an uncompromising New Dealer and a friend to
the President . . . KEEP HIM IN CONGRESS.

☞ VOTE ⊗DEMOCRATIC NOVEMBER 5th ☜

MITCHELL CAMPAIGN POSTER, 1938. Between 1934 and 1942, Arthur W. Mitchell served as U.S. representative from the First Congressional District, which included Douglas/Grand Boulevard. Originally a Republican, Mitchell switched parties during the New Deal to defeat three-term congressman Oscar De Priest. In Congress, Mitchell fought against lynching and racial discrimination in the civil service, but failed to advance a broader agenda of civil rights for African-Americans.

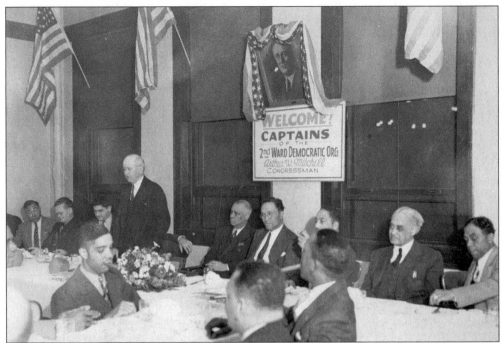

CAPTAINS OF THE SECOND WARD DEMOCRATIC ORGANIZATION, 1936. In what amounted to a sea change in American politics, African Americans deserted the Republican Party during the 1930s to join the Democratic Party of Franklin D. Roosevelt. On Chicago's South Side, black and white Democrats formed an uneasy alliance to elect Congressman Arthur Mitchell, seated to the left of the 2nd Ward sign; next to Mitchell is Earl B. Dickerson, a leading attorney, businessman, and politician from Douglas/Grand Boulevard.

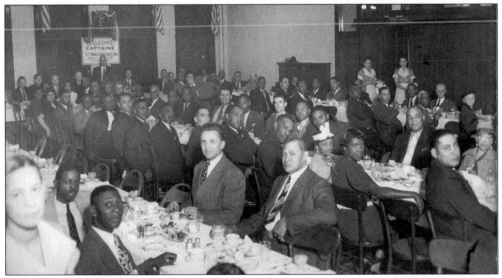

SECOND WARD DEMOCRATIC ORGANIZATION, 1936. Once a bastion of white power, Chicago's Democratic Party opened its doors to African Americans during the 1930s, enlisting scores of black precinct captains to "get the vote out" for their candidates. Here, black and white precinct captains attend a dinner for Arthur Mitchell, then running for a second term in Congress

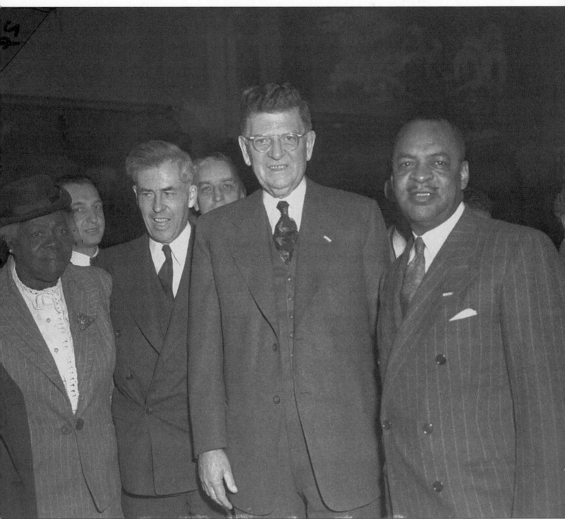

WILLIAM L. DAWSON (RIGHT) WITH VICE PRESIDENT HENRY A. WALLACE (LEFT) AND MAYOR EDWARD J. KELLY (CENTER), 1944. Originally from Georgia, William L. Dawson (1886–1970) moved to Chicago during the Great Migration and studied law at Kent College and Northwestern University. As 2nd Ward committeeman during the 1930s, Dawson helped Mayor Kelly build a powerful Democratic machine by enlisting scores of South Side voters. In 1942, Dawson won election to the U.S. House of Representatives and served 14 consecutive terms. Over the years, Dawson gradually became more moderate in his views, earning criticism from many African-Americans.

HOW WILL YOU VOTE?

JOBS
In Defense
For All Negroes
THEN VOTE FOR
☒ **DICKERSON**

OR

JOBS
In Politics
For Ward Heelers
THEN VOTE FOR
☒ **DAWSON**

50,000 JOBS FOR NEGROES: That's the demand that Alderman Earl B. Dickerson put on the desk of War Production Chief Donald Nelson (right) this week. The Dickerson Plan for War Production (discussed in a Chicago Sun editorial on the other side) represents culmination of a long crusade by Dickerson against discrimination in defense employment.

HERE IS THE CHOICE

☒ EARL B. DICKERSON

Appointed by President Roosevelt to the Committee on Fair Employment because of his record as a Negro leader in the fight against discrimination, he swiftly became the hardest fighter on the FEP for jobs for Negroes as testified by the Negro press.

Got two hearings in Chicago which led to war work for Negroes at such big local plants as Studebaker, Majestic Radio, Stewart - Warner and Hallicrafters Radio.

On a national scale the FEP has won thousands of jobs for Negroes IN AIRCRAFT, SHIPYARDS, ARSENALS AND AUTO PLANTS.

☒ WILLIAM L. DAWSON

Defeated for office six times since 1927 running as Republican, he switched over to the Democrats in cushy job as 2nd ward committeeman.

Fired all regular Democratic workers and put his GOP personal followers in jobs. Republican Richard A. Harewood, Dawson No. 1. man, got job as organization president replacing Sen. William A Wallace.

For himself - well, ask Dawson how it feels being a plumbing inspector for the Water Pipe Extension Bureau at $4000 per year WITHOUT KNOWING ANY MORE ABOUT PLUMBING THAN CHARLIE McCARTHY.

VOTE FOR JOBS AND DICKERSON

DEMOCRATIC CANDIDATE 1st DISTRICT ◄◄◄

DICKERSON CAMPAIGN POSTER. Although Chicago Alderman Earl B. Dickerson (1891–1986) lost to William L. Dawson in the 1942 race for Congress, he retained his place in Bronzeville's history. In 1940, Dickerson successfully argued against restrictive covenants before the U.S. Supreme Court (*Hansberry v. Lee*); he also served on President Roosevelt's Fair Employment Practices Committee, and as president of Supreme Liberty Life Insurance Company.

Let's Make History!

NAME THE HOUSING PROJECT

(To be erected at 37th and South Parkway)

IDA B. WELLS
(Deceased)

•

IDA B. WELLS

GARDEN

APARTMENTS

•

A FEW REASONS WHY

1. Ida B Wells as a great pioneer civic worker devoted 38 years of service to the elevation of her race.
2. She fought lynching through the press and from the platform.
3. In 1893 Ida B. Wells organized the first colored Woman's Club in Illinois and is recognized as the "Mother" of the Illinois Association of Colored Women.
4. Ida B. Wells with the aid of Jane Addams stopped the establishment of separate schools in Chicago.
5. She founded the Negro Fellowship League, the Alpha Suffrage Club and many other civic organizations.
6. She gained audiences with President McKinley to protest against lynching and conferred with President Wilson about discrimination against Negroes in Federal employ.
7. She served as the first Negro Adult Probation Officer and aided in the founding of the Wabash Y.M.C.A. and the Frederick Douglass Center.

You owe it to your race, your community and yourself to co-operate with this movement, by writing a letter to:

MR. JOSEPH W. McCARTHY

Chairman of Chicago Housing Authority

NOTICE FOR IDA B. WELLS HOMES, C. 1940. For years, community leaders like Irene Gaines and Earl Dickerson led the fight for low-income public housing in Douglas/Grand Boulevard to relieve squalid, overcrowded conditions caused by racial segregation and poverty. The Ida B. Wells Homes, built with federal money and completed in 1941, contained over 1,600 units in 124 buildings located at Thirty-seventh Street and South Park Avenue (now King Drive).

Chicago Conference
- on -
Negro Problems

CHAIRMAN

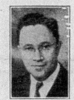

Alderman EARL B. DICKERSON

DISCUSSIONS ON - - -
Relief, Housing, Jobs, Health, Education and Schools

SPEAKERS

LILLIAN PROCTOR FALLS Ald. ARTHUR G. LINDELL LOUISE THOMPSON

HORACE CAYTON IRENE McCOY GAINES HOWARD GOULD

DR. ARTHUR G FALLS DEAN H: M. SMITH

SATURDAY, JANUARY 11, ~~1940~~ 1941
WABASH AVENUE Y. M. C. A. 3763 SO. WABASH AVE.

CHICAGO CONFERENCE ON NEGRO PROBLEMS, 1941. To address issues of community concern, 2nd Ward Alderman Earl B. Dickerson organized a conference on, among other issues, housing, jobs, and schools. Held at the historic Wabash Avenue Y.M.C.A., the conference featured such noted speakers as Irene McCoy Gaines and sociologist Horace Cayton, then working with St. Clair Drake on their future classic, *Black Metropolis: A Study in Negro Life in a Northern City.*

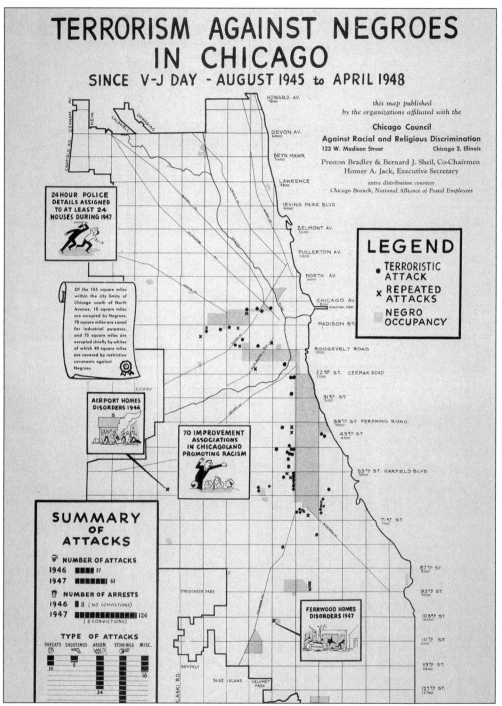

"**Terrorism Against Negroes in Chicago**," 1948. As this map reveals, racial tensions ran high during the 1940s, when black Chicagoans moved away from Douglas/Grand Boulevard into white neighborhoods in search of better living conditions. Previously, whites had used restrictive covenants to prevent home owners from selling to any "person of color," but the U.S. Supreme Court struck them down as unconstitutional in 1948 (*Shelley v. Kraemer*).

Four

URBAN RENEWAL

After World War II, Douglas/Grand Boulevard experienced great change. Just as its population had swelled during the war, so it declined afterwards; large numbers of middle-class residents, finally free of restrictive covenants, moved away from the area in what many called "The Break Out." At the same time, city planners, anxious that deteriorating conditions on the South, West, and North Sides were adversely affecting the Loop, launched a major program of urban renewal that radically altered the neighborhood's physical landscape, as well as its social fabric. Without constructing replacement housing for middle-class residents ineligible for public housing, the city leveled many residential areas to expand IIT, Michael Reese and Mercy Hospitals, and to build private (Lake Meadows, Prairie Shores) and public (Stateway Gardens, Robert Taylor Homes) housing projects, as well as the Dan Ryan Expressway. Chicago's decline as an industrial center further affected Douglas/Grand Boulevard; when the stockyards and steel mills closed, thousands of people lost their jobs, creating high unemployment which spawned a myriad of social problems, including poverty, increased crime, drug use, and gang violence. Ultimately, changes during the post-war period had a devastating effect upon Douglas/Grand Boulevard, making it one of Chicago's poorest neighborhoods by the 1970s.

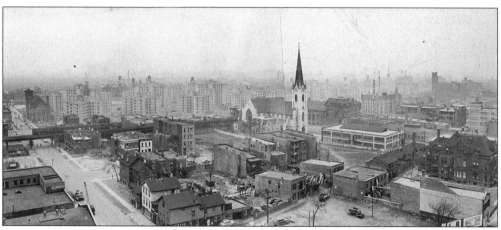

AERIAL VIEW OF DOUGLAS, 1955. (COURTESY ST. JAMES CHURCH.) As evidenced by this photograph, urban renewal transformed Chicago's South Side. Rising in the distance beyond St. James Church (center) is Stateway Gardens, a massive low-income housing project completed in 1958. Additional South Side landmarks include the elevated train (left), old Mercy Hospital (right of St. James), and the Gates Mansion (far right).

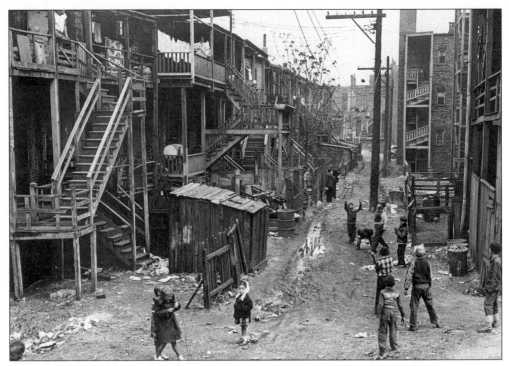

VIEWS OF DOUGLAS, 1951. As recorded by Chicago photographer Mildred Mead, living conditions in Douglas/Grand Boulevard became intolerable after World War II. Pictured above is an alley between Ellis and Cottage Grove Avenues, near Michael Reese Hospital, later cleared for Prairie Shores apartment complex. The below picture shows the thirtieth block of Federal Street, future site of Stateway Gardens, a massive public housing project for low-income residents.

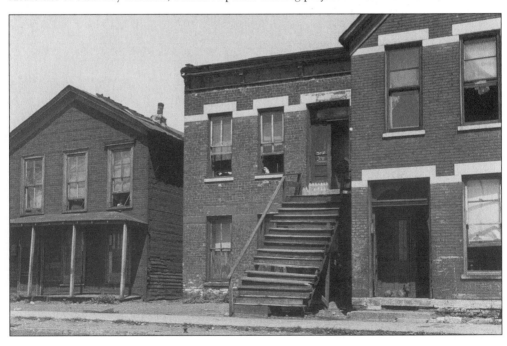

REBUILDING OLD CHICAGO

CITY PLANNING ASPECTS OF THE NEIGHBORHOOD REDEVELOPMENT. CORPORATION LAW

REPORT FROM THE CHICAGO PLAN COMMISSION, 1941. This report from an advisory panel headed by Mayor Edward J. Kelly called for constructing new row houses on the South Side for middle-income residents with funds from the government and private investors. With the notable exception of Lake Meadows, developed by the New York Life Insurance Company, the hoped-for collaboration never materialized,.

PROPOSED PUBLIC HOUSING SITES, 1949–50. As this map shows, most public housing units would be built in the inner city, where the greatest numbers of low-income people lived and not in surrounding white neighborhoods. Eventually, "C" Area (#3) included Stateway Gardens, built in 1958, and the Robert Taylor Homes, completed in 1962.

BEWARE OF
SLUM CLEARANCE
(NEGRO CLEARANCE)
Negroes in Chicago - Tenants and Property Owners
BEWARE! **BEWARE!** **BEWARE!**
of the
South Side Action Committee, Michael Reese Hospital
Illinois Institute, Southside Planning Board,
University of Chicago, Loop Stores
They are all working to fool the Negroes into selling, thereby
ousting not only the Landowners but the thousands
of tenants as well.
**You owe it to yourself to wake up and to answer the
following questions.**

1. Do you want to stay near the cool lake breezes?
2. Do you want to be pushed to the outskirts of town?
3. Do you want to be fleeced out of your lifetime earnings by having any property you may buy anywhere condemned as slums?
4. Do you want to be cheated out of the best part of the City by those who "Bombed and ran" and now want it back?
5. Do you want to be the goat of agencies who should help drive out the vice and dangers of the South side for you instead of doing it after driving you out.

6. Do you business men want to lose your small businesses and thereby your chance to make an honest living?
7. Do you professional men want to wake up without any clients and patients?
 Can you buy your office building now, will they sell to you?
8. Do you ministers want your churches left standing without your congregations?
9. Do you want to lose your tax payers? (Tenants are the property owners of tomorrow. Every time they pay rent they help pay your taxes)

Avoid these evils.

1. Don't let them tell you it won't be in your lifetime.
2. Sign petitions fighting the proposition.
3. Support your fighting neighborhood organizations.
4. Put pressure on your political leaders now.
5. Rebuild, keep up and improve your own community.

6. Hold onto your property.
7. Make your leaders defend you and unmask friends who are wolves in sheeps clothing.
8. Make the Negro Press print articles defending you. You Buy Them

Pass this handbill on to friends and tell them to tell their friends
to tell their friends. Unity and Right with a little Fighting Spirit
will win! We must be united! We must organize to fight and win
this battle to hold the South Side for Negroes.

CITIZENS' BROADSIDE, C. 1945. Many South Siders opposed urban renewal and fought to keep their community intact through grass-roots efforts. A broadside warning African Americans about "Negro Clearance" urges them to sign petitions, support neighborhood organizations, pressure political leaders, and not sell their property in an effort to "hold the South Side for Negroes." In addition to homeowners, the notice appealed to business and professional leaders, including the clergy.

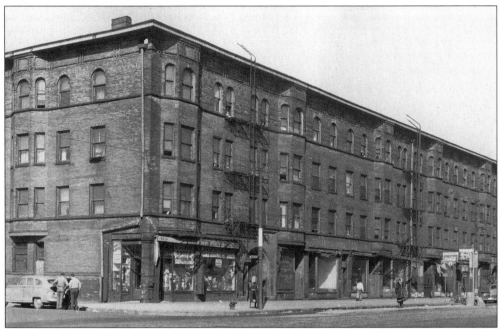

Mecca Flats, Thirty-fourth and State Streets, 1951. Joining the city's urban renewal efforts, the Illinois Institute of Technology decided to remain on the South Side and expand their facilities by clearing nearby blighted areas. Their plans called for razing Mecca Flats, a four-story, 374-unit apartment building originally constructed to accommodate visitors to the 1893 World's Columbian Exposition.

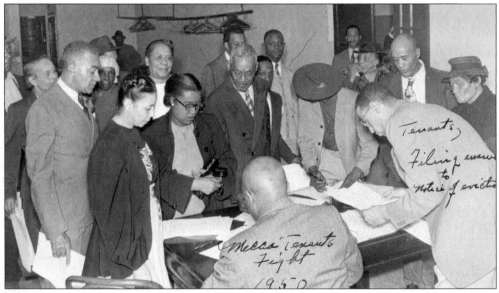

Mecca Tenants Filing Petition Against Eviction, 1950. After IIT announced plans to demolish Mecca Flats, tenants filed petitions against eviction with city and state officials. At the time, about 1,200 people lived in the building, which had deteriorated badly during the Great Depression and World War II. A similar protest action in 1943 delayed demolition, but this time the effort failed.

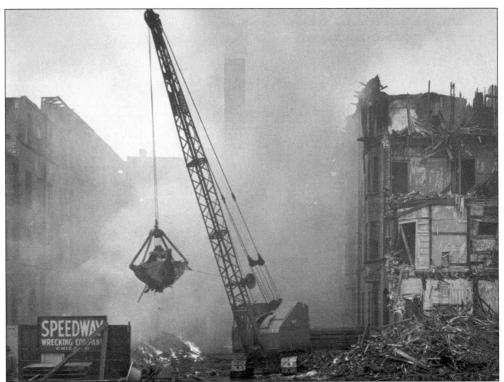

WRECKING THE MECCA, 1951. Citing health and safety issues, IIT started razing Mecca Flats during the Christmas holidays. On January 10, 1952, a sudden fire sent flames soaring 50 feet into the air, devastating the entire southeast section.

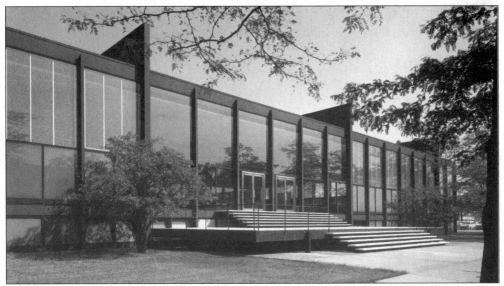

CROWN HALL, BY HEDRICH-BLESSING PHOTOGRAPHERS, 1955. Demolishing the Mecca and several other buildings along State Street made it possible for IIT to build a new campus, designed by internationally renowned architect, Mies van der Rohe. Crown Hall, considered by many to be a masterpiece, sits where Mecca Flats once stood.

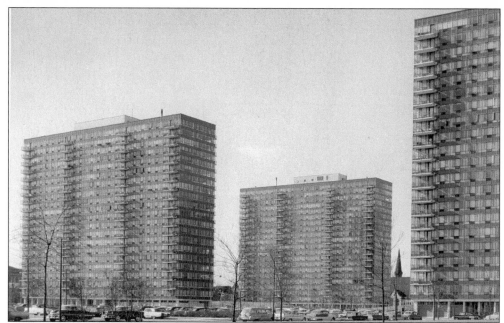

LAKE MEADOWS, C. 1960. Privately developed by New York Life Insurance Company during the 1950s, Lake Meadows included ten buildings with more than 2000 apartments, a shopping center, swimming pool, tennis courts, and children's play lots. First preference for occupancy went to African-American families displaced by the project, but those unable to pay the rent moved to public or private housing units elsewhere in Chicago, or moved away from the city.

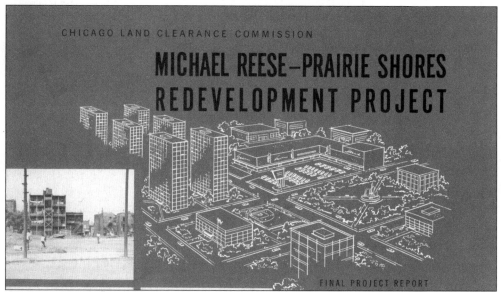

PRAIRIE SHORES PAMPHLET, C. 1960. Developed by Michael Reese Hospital primarily for its own staff, Prairie Shores consisted of five buildings with 1,700 apartments. To make way for the complex, more than eight hundred African-American families were displaced; two hundred families voluntarily left before construction began, while another two hundred relocated to public housing units. The rest moved to private rental or sale units in other parts of Chicago or left town.

ARCHIBALD CAREY JR., 1948. In 1949, Third Ward Republican alderman, Reverend Archibald Carey Jr., proposed an open-housing ordinance making it unlawful to discriminate in the sale or rental of property based on race, color, creed, national origin, or ancestry. Directed at Lake Meadows, which used quotas to maintain racial balance, the "Carey Ordinance" unleashed a furious debate across the city before the white-controlled City Council voted it down, 31–13.

WESTERN UNION

1201

W. P. MARSHALL, PRESIDENT

The filing time shown in the date line on telegrams and day letters is STANDARD TIME at point of origin. Time of receipt is STANDARD TIME at point of destination

```
LD185 EM PD
          CHICAGO ILL FEB 28 1949 1219P
ALDERMAN A J CAREY JR
               COUNCIL CHAMBERS CITY HALL CHGO
  2000 RESTAURANT WORKERS ENDORSED YOUR ORDNANCE WHICH IF PASSED
  WILL ASSURE US AN OPPORTUNITY TO LIVE IN DECENT HOMES. THIS IS
  A BILL FOR THE PEOPLE AND WE WANT YOU TO KNOW THAT WE THE PEOPLE
  ARE SOLIDLY BEHIND YOU
               THEODORE W MCNEAL PRESIDENT LOCAL 444
                                    1232P
```

TELEGRAM IN SUPPORT OF THE CAREY ORDINANCE, 1949. The first of its kind proposed in Chicago, the Carey Ordinance enjoyed widespread support among African-Americans, many of whom sent telegrams of encouragement. Conversely, most white Chicagoans viewed the measure as a threat to their neighborhoods and flooded Carey's office with postcards expressing their views.

URBAN RENEWAL, 1962. Between 1960 and 1962, students in Margaret Burroughs's art classes at Du Sable High School sketched their impressions of urban renewal. This view of building the Robert Taylor Homes along State Street captures the disruptive process, which displaced many dilapidated, yet familiar buildings and businesses in the community.

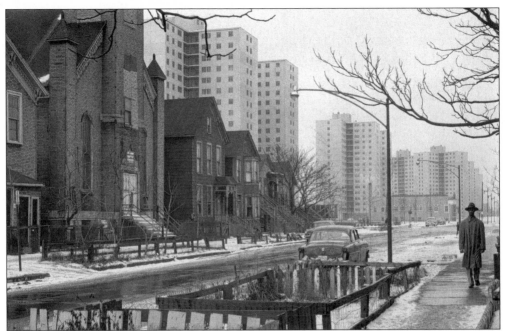

DEARBORN STREET LOOKING NORTH TO STATEWAY GARDENS, 1959. As a result of urban renewal, high-rise apartment buildings replaced low-rise dwellings of a more human scale, a process that destroyed familiar landmarks and eroded people's connections to the past. In addition, the high concentration of poverty led to additional problems, including crime, drug use, and gang-related activities that disrupted many lives.

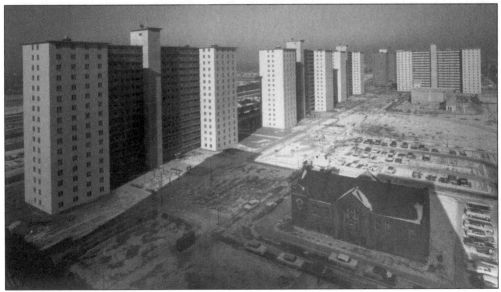

ROBERT TAYLOR HOMES, 1962. Built by the federal government for $68 million, the Robert Taylor Homes, stretching between Thirty-ninth and Fifty-fourth Streets, consisted of 28 16-story buildings with more than four thousand apartments. Although the massive project provided many African Americans with decent housing for the first time in their lives, the large concentration of poverty and building mismanagement soon created a new set of difficult problems.

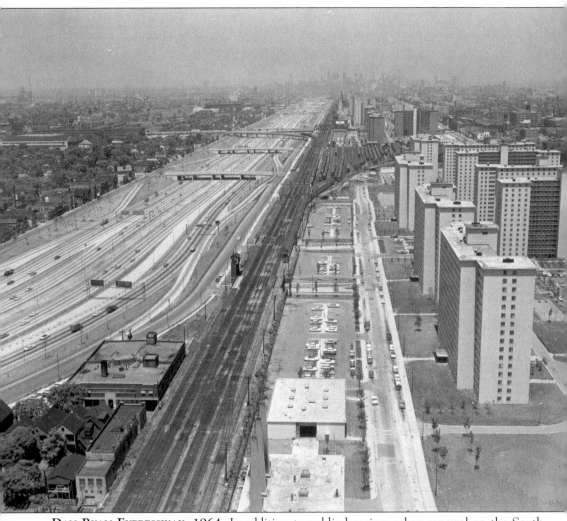

DAN RYAN EXPRESSWAY, 1964. In addition to public housing, urban renewal on the South Side resulted in the Dan Ryan Expressway, which improved Chicago's north-south traffic flow, but formed a nearly insurmountable barrier between Douglas/Grand Boulevard and the rest of the city. To the right of the expressway are the Chicago, Rock Island & Pacific Railroad tracks and Robert Taylor Homes. Further north are the Staeway Gardens.

Five

REVITALIZATION

Although Douglas/Grand Boulevard changed dramatically as a result of urban renewal, many churches, businesses, social organization, and individuals remained in the neighborhood and continued to seek solutions to build a better future for themselves and their children against great odds. During the 1970s, grass-roots efforts to revitalize the neighborhood resulted in restoring "The Gap," an area spared urban renewal's wrecking ball. Preservation efforts spearheaded by community organizations such as the Mid-South Planning and Development Commission, and supported by city, state, and federal dollars, have resulted in landmark status for several buildings that have been or are being restored. In addition, the federal government has directed the demolition of several public housing units, including some at Robert Taylor. According to a ruling by the U.S. Supreme Court, displaced public-housing residents must be relocated in low-rise, scattered-site developments across the city and suburbs. Although revitalization efforts have resulted in physical improvements on the South Side, they have not transpired without controversy. Many residents question the eventual outcome—will the South Side remain home for low-income African Americans or become an upscale neighborhood for wealthier Chicagoans? Or can it become a mixed-income neighborhood, as it was during the late nineteenth century? Will the future of Douglas/Grand Boulevard be shaped by its current residents, or controlled by outside forces? The book's last chapter will present a brief overview of recent developments in Douglas/Grand Boulevard.

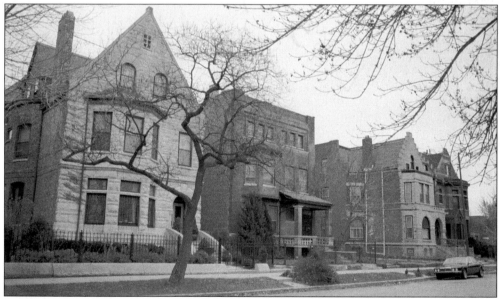

"THE GAP." Spared from urban renewal, an area known as "The Gap" between Indiana Avenue and King Drive from Thirty-first to Thirty-fifty Streets recalls old Chicago. In addition to row houses designed by Frank Lloyd Wright, the area includes several homes restored during the 1970s and 1980s by African-American professionals who moved back to the South Side.

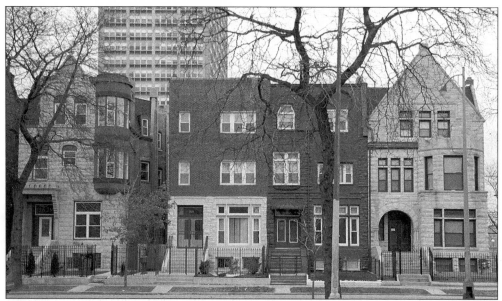

MARTIN LUTHER KING JR. DRIVE. Formerly known as Grand Boulevard, and later as South Parkway, Martin Luther King Jr. Drive remains the main thoroughfare of Douglas/Grand Boulevard. Recently, middle and above-income African Americans have returned to the area, restoring many of the boulevard's fine homes, returning one of Chicago's most beautiful streets to its former glory. In addition, the City of Chicago has installed a monument to the Great Migration at Twenty-sixth Place, a "Bronzeville Walk of Fame" between the monument and Thirty-fifth Street, and decorative benches at several bus stops.

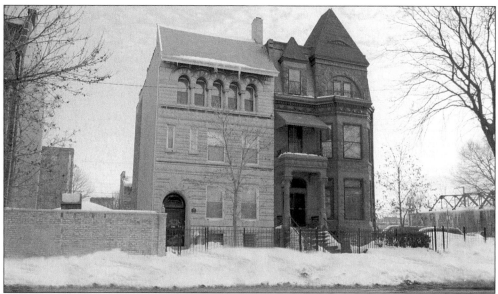

THIRTY-FOUR HUNDRED BLOCK OF SOUTH MICHIGAN AVENUE. Despite the ravages of urban renewal, many Victorian homes still stand in Douglas/Grand Boulevard. Recently, an increasing number of middle and upper-middle-class African Americans have purchased and restored these homes, causing property values to rise. As this trend continues, many people wonder if lower-income residents will be able to remain in the neighborhood.

118

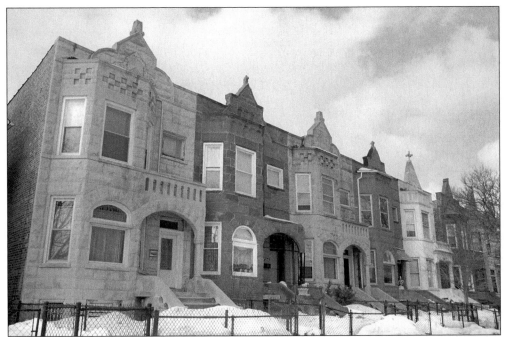

FORTY-FIVE HUNDRED BLOCK OF FORRESTVILLE AVENUE. An entire block of well-maintained structures along Forrestville Avenue provides a glimpse into Douglas/Grand Boulevard's past when single-family, two-story homes lined the streets. Although the homes' interiors may have been altered, their exteriors remain largely intact, serving as a model for homes recently constructed one block to the east along St. Lawrence Avenue.

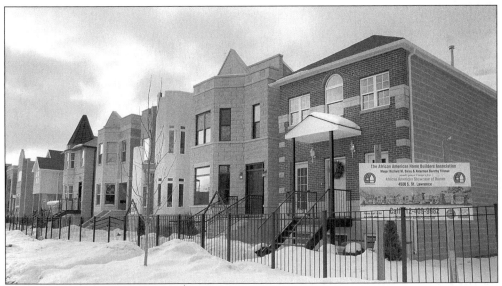

FORTY-FIVE HUNDRED BLOCK OF ST. LAWRENCE AVENUE. Constructed by African-American developers for middle-class residents, the African American Showcase of Homes on St. Lawrence Avenue attempts to re-create the charm of historic Bronzeville. The developers, who joined together to form the African American Home Builders Association, contributed $2 million to the effort, strongly supported by Mayor Richard M. Daley and Alderman Dorothy Tillman.

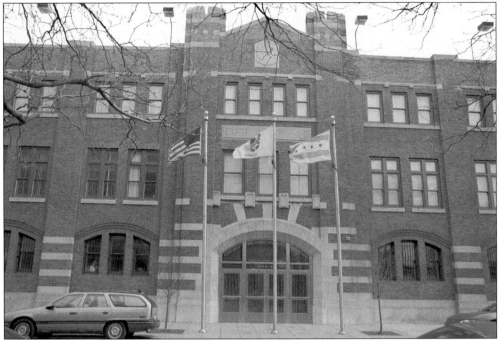

CHICAGO MILITARY ACADEMY, BRONZEVILLE. Built in 1914–15, the historic Eighth Regiment Armory at 3533 South Giles Avenue reopened in 1999 as a military academy. Efforts to restore the building, which had fallen into serious disrepair, cost $14 million. Although most students are from Douglas/Grand Boulevard, other neighborhoods are represented as well, and the school is gaining a reputation for academic excellence.

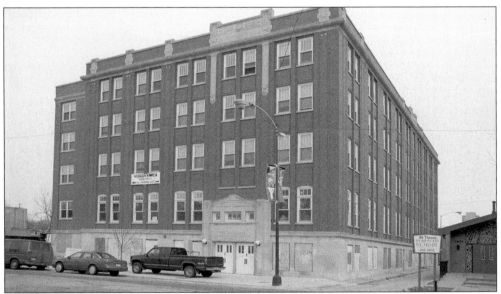

THE WABASH YMCA. Although neglected for decades, the Y remained intact with few alterations to its exterior or interior. It is currently being restored as the Rennaisance Apartments and Fitness for Life Center, which will include rental units for low-income single men. The effort is supported by city, state, and federal funds.

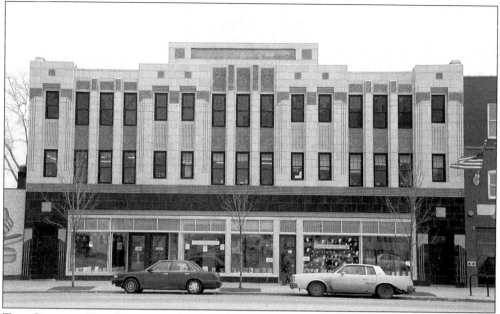

THE CHICAGO BEE BUILDING, 3647–55 SOUTH STATE STREET. Built between 1929 and 1931, Anthony Overton's Art Deco-style Chicago Bee Building was restored in the mid-1990s by the Mid-South Planning and Development Commission and the city as a branch of the Chicago Public Library. For many residents of Douglas/Grand Boulevard, the building remains a powerful symbol of black enterprise and independence.

OVERTON HYGIENIC BUILDING, 3619–27 SOUTH STATE STREET. Built between 1922–33, the Overton Hygienic Building originally housed Anthony Overton's bank, insurance company, and cosmetics firm along with several smaller companies and numerous professionals. Currently, the Mid-South Planning and Development Commission is restoring the structure as retail and office space, using city, state, and federal dollars; completion is scheduled for the year 2002.

THIRTY-FIFTH STREET ELEVATED STATION. Recently rebuilt, the station pays homage to historic Bronzeville and provides a sense of place and identity in the urban landscape. A brightly colored mosaic and bronze plaques on the front of the building, and a mural on its west side, spotlight famous neighborhood people and landmarks, including the Chicago Bee Building, the Wabash Avenue YMCA, the Eighth Regiment Armory, and the Supreme Liberty Life Insurance Building.

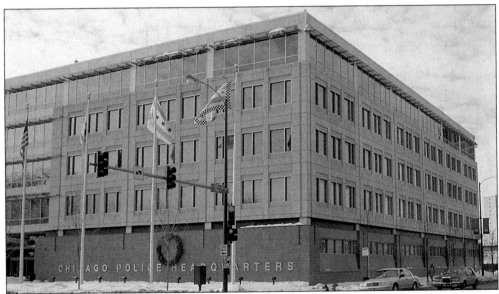

CHICAGO POLICE HEADQUARTERS, THIRTY-FIFTH STREET AND MICHIGAN AVENUE. Built for $65 million, Chicago's new police headquarters opened in June 2000. The 360,000-square-foot facility features a high-tech command center, 600-seat auditorium, multi-media center, and administrative offices for 1,200 employees. According to Mayor Richard M. Daley, the facility is "a long-term investment—in the safety of our residents, the safety of our police officers, and in the Bronzeville community."

THIRTY-FIFTH STREET. As in the past, Douglas/Grand Boulevard is a study in contrasts. This view of Thirty-fifty Street, taken between Wabash Avenue and State Street, includes the recently renovated elevated train tracks, a modern high-rise building occupied by Illinois Institute of Technology, Stateway Gardens public housing project, and in the distance, Comiskey Park, home of the Chicago White Sox.

STATEWAY GARDENS. Completed in 1958, Stateway Gardens is Douglas/Grand Boulevard's second largest public housing project, after the Robert Taylor Homes. with1,684 units. Currently, some buildings (center) are being demolished as part of the federal government's program to relocate public housing residents in scattered site housing across the city and suburbs.

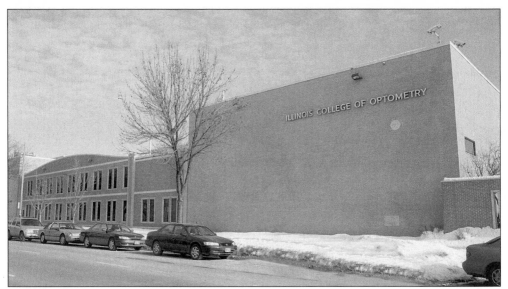

ILLINOIS COLLEGE OF OPTOMETRY, 3241 SOUTH MICHIGAN AVENUE. Established in 1872, the Illinois College of Optometry is the country's first and largest educational facility dedicated to teaching optometrists. In addition, the college operates the Illinois Eye Institute, which provides care for 50,000 patients a year, mostly from the surrounding neighborhood, and "Visions of Hope," a new program aimed at ten thousand adults at risk of going blind.

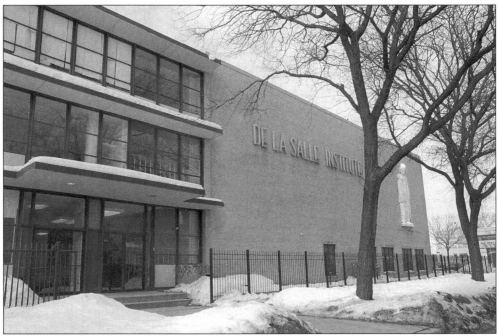

DE LA SALLE INSTITUTE (MICHIGAN AVENUE ENTRANCE). Founded in 1889, De La Salle is one of several institutions that have remained in Douglas/Grand Boulevard for over a century. This contemporary addition was dedicated in 1962; the school's original building at Thirty-fifth and Wabash was demolished in 1984. A Catholic, four-year high school, De La Salle currently enrolls about nine hundred white, African-American, Hispanic, and Pacific Asian-American students.

FUTURE SITE OF IIT's McCORMICK TRIBUNE CAMPUS CENTER. As designed by Rem Koolhaas of the Netherlands, IIT's new campus center will consist of a one-story, glass building situated on the west side of the CTA tracks, with a contoured concrete roof and a steel tube to encase the train line as it crosses over the building. Funded by the McCormick Tribune Foundation, the center is scheduled for completion in fall of 2002.

SOUTH SIDE COMMUNITY ART CENTER, 3831 SOUTH MICHIGAN AVENUE. Since its founding by the Works Progress Administration in 1940, the South Side Community Art Center has been a leading cultural institution in Chicago's African-American community. Over the years, many noted artists have been associated with the center, including Gordon Parks, Gwendolyn Brooks, Margaret Burroughs, and Archibald Motley Jr. Today, the center continues to sponsor exhibitions and art classes.

125

Elliott Donnelley Youth Center, 3947 South Michigan Avenue. As part of the CYC (Chicago Youth Centers), the Elliott Donnelley Youth Center serves neighborhood youth with a variety of educational and recreational programs throughout the year. In 1995, the center installed a new playground and an art park with works by several Chicago artists, including Mr. Imagination (below). The colorful mural depicts scenes from the Great Migration and historic Bronzeville.

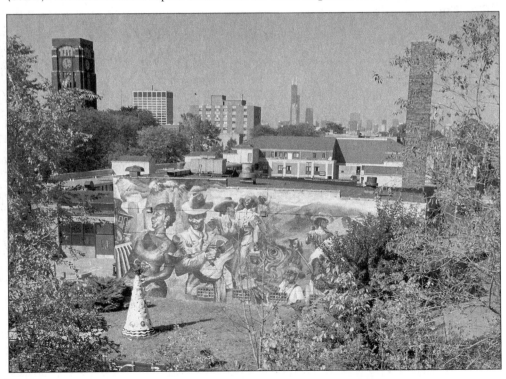

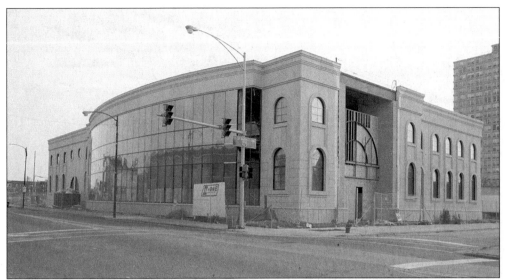

FORTY-SEVENTH STREET CULTURAL CENTER AND LOU RAWLS THEATER. Located just north of a vacant lot once occupied by the Regal Theater, this structure anchors an effort led by Chicago Alderman Dorothy Tillman to develop the area bordering Forty-seventh Street as an entertainment and shopping district that will attract tourists, but critics charge that Tillman did not seek community input and that current plans to create a blues district are historically inaccurate.

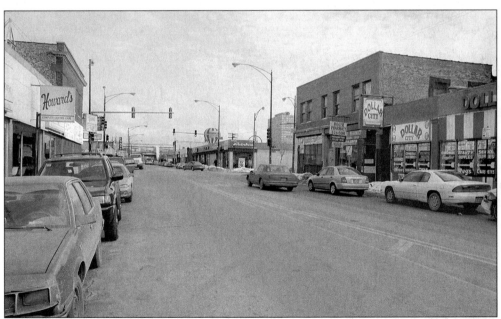

FORTY-SEVENTH STREET BETWEEN INDIANA AND MICHIGAN AVENUES. According to plans developed by the Mid-South Planning and Development Commission, and approved by the city council in May 1997, most businesses along Forty-seventh Street are considered "commercial/redevelopment opportunities." If plans proceed, they will be replaced by blues clubs that supporters believe will revitalize the street, turning it into a tourist destination readily accessible from both the Dan Ryan Expressway and Lake Shore Drive.

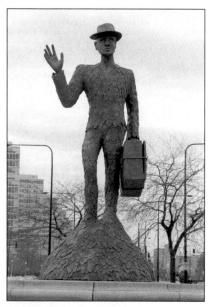

MONUMENT TO THE GREAT NORTHERN MIGRATION, TWENTY-SIXTH PLACE AND KING DRIVE. This contemporary monument pays tribute to all African Americans who moved north to Chicago during the Great Migration. The 15-foot-tall bronze figure carries a worn suitcase tied together with rope; he is completely covered with shoe soles, "worn and full of holes," to symbolize the often difficult journey made by thousands of migrants bound for freedom.